Decorative Painting

Flowers and Finishes

SANDY BARNES

SEARCH PRESS

First published in Great Britain 1998

Search Press Limited
Wellwood, North Farm Road,
Tunbridge Wells, Kent TN2 3DR

Text copyright © Sandy Barnes 1998

Photographs by Search Press Studios
Photographs and design copyright © Search Press Ltd.
1998

ISBN 0 85532 866 5

For more information on decorative painting, contact:

The Secretary,
The British Association of Decorative and Folk Art
1 Bentley Close, Horndean, Waterlooville
Hants, PO8 9HH, England

or write to the author at:

Walnut Tree Cottage, Willersey, Nr. Broadway
Worcestershire, WR12 7PJ, England

Suppliers

If you have any difficulty in obtaining any of the materials
and equipment mentioned in this book, then please write to
the publishers for a current list of stockists, which includes
firms who operate a mail-order service:

Search Press Limited, Wellwood,
North Farm Road, Tunbridge Wells,
Kent TN2 3DR, England

Publisher's note

All the step-by-step photographs in this book show the
author, Sandy Barnes, demonstrating decorative painting.
No models have been used.

Colour separation by P&W Graphics, Singapore
Printed in Spain by Elkar S. Coop. Bilbao 48012

*A special thank you to Michael Kay for his
support and generosity.*

*Also, thank you to Roz, Chantal, Julie and
Lotti of Search Press, for their help and
patience during the studio work and
compilation of this book.*

*Many thanks to Sue Goodhand for supplying
all the wooden items that I have painted in this
book. A mail order catalogue can be obtained
from: Goodhands Decorative Folk Art, 1
Bentley Close, Horndean, Waterlooville,
Hants PO8 9HH, England.*

*Thank you to Julie Hickey for supplying the
photograph featured on page 13.*

*Finally, thank you to all my students for their
friendship and loyalty over the years – may we
share many more happy hours of painting
together.*

Contents

Introduction

Decorative painting is a general term used to encompass all forms of painting for decorative purposes. It is a huge umbrella that covers many decorative styles, but my particular interest is in realistic florals. I enjoy both painting and growing flowers – in fact I am gradually working my way through my garden, trying to paint new blooms each year.

The history of decorative painting can be traced back some twenty thousand years, to paintings on cave walls. Ever since, people have followed this tradition of decorating their homes, taking their inspiration from images of everyday life.

My interest in painting developed at the end of the 1980s, while I was living in Australia. There, I was introduced to traditional folk art painting. This form of painting originated in Europe in the sixteenth century. At that time, country folk such as farmers, carpenters and cabinet-makers, would often occupy their time during the long winters by making, repairing and decorating simple pieces of furniture. Religion was an important part of people's lives, and religious symbols such as the heart (a symbol of love), the tree (a symbol of the earth) and the tulip (a symbol of the Holy Trinity), were widely used in designs. Pigments for paint were found in their surroundings: black soot from fires; white from lime; and green, blue and yellow from flowers and plants.

By the early eighteenth century, the growing middle classes were striving to find ways to emulate the trends of the aristocracy. They could not afford the fine timbers of the nobility, so they began to copy them using stencils and glazes. By the middle of the century, the covering of woodwork with a full coat of coloured paint and colourful designs became very popular. The influence of the rococo style meant that colours soon became bright and clear, and flowers in art and crafts became more realistic.

When I first came across decorated furniture in Australia, my reaction was 'it is lovely, but I could never do that – I cannot paint'. However, I was finally persuaded that anyone could do it . . . so I had a go. After one class, I was hooked and I have never looked back. That first encounter with folk art taught me that all you need to succeed, is a

willingness to learn. You do not need drawing ability, as designs are readily available in our everyday surroundings: magazines, cards, books, posters, fabrics and wallpapers, for example, all provide plenty of inspiration. Outlines can then be traced, enlarged or reduced with the aid of a photocopier, and these 'designs' can be painted by combining a series of easily learnt brushstrokes and techniques.

In this book, I do not go into great detail about the various brushstrokes that are used in decorative painting – there are lots of wonderful folk art books which explain these clearly. Instead, I have concentrated on two techniques: side-loading and pat-blending. Both techniques involve firstly basecoating your flower or leaf in colouring-book fashion, then building up additional layers of paint on top of the flat basecoat to create a three-dimensional appearance. You will soon discover that both techniques are easy to master and are an excellent way of creating beautiful and realistic flowers and foliage.

In this book, I have also included examples of decorative background treatments, such as sponging, texturing, marbling, and crackle finishing. I try to avoid painting a background in a single flat colour, as

this can look quite uninspiring. Instead, I show you how to create interesting effects and textures which can then be over-decorated with flowers – in this way, pieces of furniture can be totally transformed.

I have included patterns for all the project designs. The enlargement specified will increase the pattern to the size that I used. However, these patterns can be enlarged on a photocopier to suit the piece you wish to decorate. I would not recommend that they are reduced in size.

The designs featured in this book are very versatile and can be used as shown or painted on your own individual pieces of furniture. If you prefer to create pictures to hang on the wall, simply paint the designs on pieces of MDF (medium density fibreboard), then frame them. Whatever your preference, I hope you enjoy painting these designs, and will soon have the confidence to create your own.

Materials and equipment

Brushes

The selection of brushes available in art shops can be very confusing. It is worth investing in a good quality basic set of brushes – you cannot expect to achieve good results when using inferior ones. For decorative painting in general, choose synthetic brushes designed specifically for use with acrylic paint, as the hairs should snap back to their original shape when used. Most manufacturers now include a range recommended for decorative stroke work. Choose brushes with short handles.

If you look after your brushes carefully, they should last a long time. Always wash brushes thoroughly with pure soap immediately after use. Reshape while damp and allow to dry on a flat surface.

1. **Mop brush** A soft brush used in the realistic marbling effect.

2. **Flat or wash brush** The hairs taper to a sharp chisel edge. Choose a size where the length of the hairs is greater than the width – generally, a No. 6 or 8.

3. **Liner brush** A thin brush with a very fine point. It is available in various lengths. Choose one about 1.5cm (½in) long.

4. **Round brush** The hairs taper to a good point from a full body. Choose a small size (a No. 1 or 2) and a medium size (a No. 4 or 5).

5. **Filbert brush** This is similar to a flat brush but it does not have corners. Choose a No. 3 or 4.

6. **Basecoating brush** Choose a 2.5cm (1in) basecoating brush for good coverage.

7. **Stipple brush** A small, round bristle brush. It is available in various lengths. Choose one about 0.5cm (¼in) long.

> **Note**
>
> When loading a brush with paint, try not to allow the paint to enter the metal ferrule of the brush.
>
> Never leave brushes standing in water, and do not allow paint to dry on brushes.

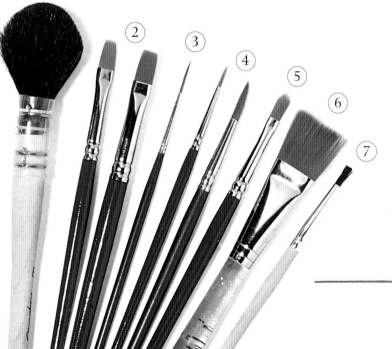

Paints

I have used acrylic paint for all the projects in this book. Acrylic paint is non-toxic, water-soluble, quick-drying and it provides a hard-wearing surface. It can be used thickly to imitate the appearance of oil paint, or it can be thinned with water and used as a watercolour. Although acrylic paint dries to provide a very resilient finish, you can varnish or wax your work to give an even tougher surface; this will also enhance the colours.

There are many brands of acrylic paint available, and there is a wide choice of colour. I have included a colour conversion chart at the end of the book for the paints I have used. Each brand of acrylic paint varies in consistency, colour-fastness, degree of coverage and price. To start with, I would recommend a make specifically designed for decorative painting. Remember that the quality of a paint is usually reflected in the price, so choose the best quality that you can afford.

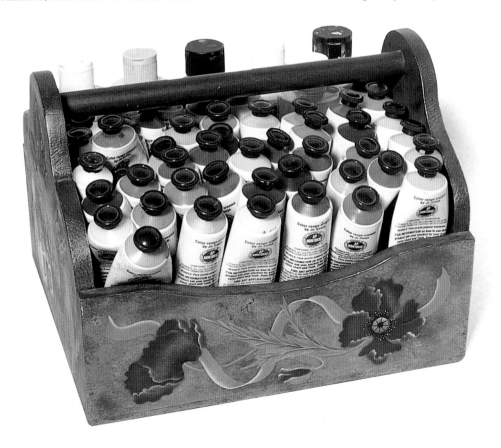

Other materials and equipment

Once you have selected your brushes and paints, you will need a few other basic supplies . . . and then you will be ready to begin decorative painting.

1. **Hairdryer** This is used to speed up the drying of acrylic paint.

2. **Mediums** These can be added to acrylic paint to enhance or change its performance. A variety are available, including retarder (slows down the drying time) and extender (thins the viscosity).

3. **Fine water spray** You can use this to prevent your wet palette from drying out.

4. **Jar** This can be filled with water and used for rinsing brushes.

5. **Masking tape** This is used to secure tracing and transfer paper into position. It can also be used to mask off areas when basecoating.

6. **Absorbent paper** This is used to blot off excess water from brushes.

7. **Pure soap** Wash brushes in pure soap after use.

8. **Ceramic tile** A tile provides an ideal surface to work on when loading and blending paint into brushes.

9. **Palette knife** You can mix paints together using this.

10. **Wet palette** Decanted paint should be stored in a wet palette.

11. **Ruler** Use a ruler, thinned paint and an ink nib to draw straight lines.

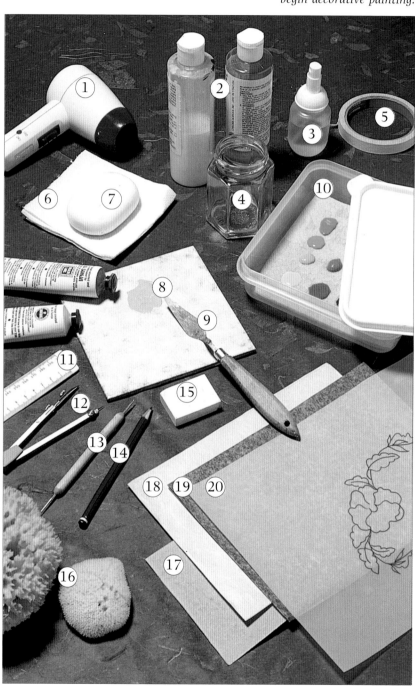

The basic materials and equipment needed to begin decorative painting.

12. Compass with ink nib
These can be used with thinned paint to draw curved lines.

13. Stylus This is used for tracing around a pattern when transferring a design. It can also be used to apply dots of paint.

14. **Pencil** A soft pencil or a felt-tip pen can be used to trace a design on to tracing paper.

15. **Eraser** Transfer lines can be removed with an eraser.

16. **Coarse and fine sponge** Paint can be applied with either a coarse or fine sponge (or both) to create a background.

17. **Sandpaper** Wooden surfaces should be sanded prior to painting.

18. **White transfer paper**
This is used to transfer a design on to a dark background.

19. **Black transfer paper**
This is used to transfer a design on to a light background.

20. **Tracing paper** Designs can be traced and then transferred on to your painting surface.

Suitable surfaces

There is an expression that decorative painters use: 'if it stands still long enough, paint it.' Provided you prepare the surface correctly (see page 12), you can paint on anything. I prefer to use wood or metal as a base for my designs. Furniture is ideal (either new or second-hand), or ready-made blanks like those shown below. Ready-made blanks are available from craft suppliers, and you will find an endless source of second-hand furniture in junk shops or at car boot sales crying out to be transformed.

Examples of items suitable for decoration.

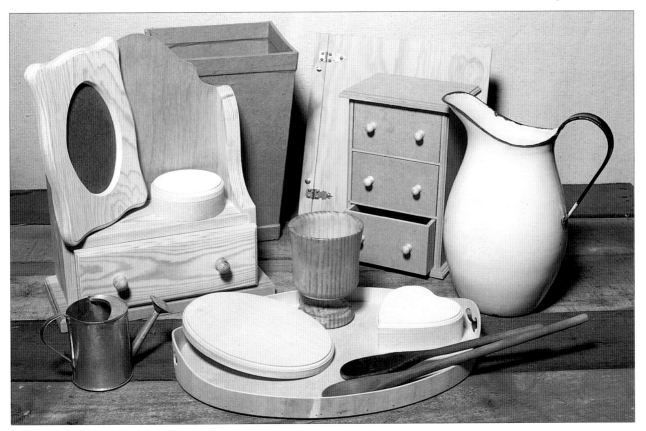

Getting started

Your workspace

Light is essential for painting. Try to work in an area where you have a good source of natural light, or alternatively you can use a daylight electric light bulb.

Arrange your workspace in an orderly manner. Place the item you will be decorating in front of you. If you are right-handed, place any equipment that you will be using frequently (water jar, absorbent paper, palette, paints, brushes and tile) to your right; if you are left-handed, place these items to your left. Setting up in this way will prevent you from having to constantly reach across your piece as you are working. Items which you require less frequently can be placed on the other side.

Mixing the paints

Some of the projects in this book involve using colours obtained by mixing two or more paints together. For example, a peach colour might be made by mixing three parts warm white with one part red earth. Throughout this book, if a colour is obtained by mixing it will appear, for example, as: peach (warm white + red earth, 3:1).

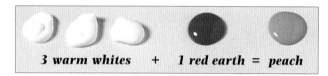

3 warm whites + 1 red earth = peach

1. Squeeze the paint on to a mixing palette. I have used a ceramic tile for a palette, but you can use tin foil or waxed paper if you prefer.

2. Mix the colours together using a palette knife.

3. Continue mixing until you have a smooth, even colour. This mixture can now be transferred to your wet palette (see opposite).

Keeping paints fresh

Acrylic paints dry quickly once decanted from their tubes or jars and exposed to air. However, this drying process can be slowed down if the pools of paint are stored in an airtight container. Paints stored in this way can be kept useable for weeks.

Various brands of wet palette are available in art shops, but you can easily make your own.

1. Spray a piece of absorbent paper with water.

2. Cut a flat sponge to fit into the base of your container. Dampen the sponge, then stretch the damp absorbent paper over it.

3. Wrap the edges of the absorbent paper underneath the sponge then place this parcel into an airtight plastic container.

4. Decant small pools of paint into the palette. Put the airtight lid back on the plastic container when the paints are not in use.

Note

Use distilled water rather then tap water when making up your wet palette. This will prevent bacteria from forming and so will keep the wet palette fresher for longer.

The sponge must always be kept damp. If it begins to dry out between painting sessions, spray with a little water.

If a skin forms over the pools of paint, spray the inside of the lid with water, close the palette and leave overnight. The pools of paint will absorb the moisture, and the skin will disappear.

Surface preparation

The surface preparation of an item you wish to paint, is an unexciting but crucial stage. If you hurry or cut corners when preparing the surface, the finished piece will often be disappointing.

New wood Fill any holes or cracks with wood filler. Rub over with medium grade sandpaper to remove any rough spots. If the surface is very rough, use coarse grade sandpaper to begin with. Finish off with fine grade sandpaper to leave a smooth surface. Wipe the surface with a damp sponge to remove any dust. The surface is now ready for basecoating. Some brands of acrylic paint contain a sealer; others need to have sealer added to them to make them suitable for basecoating. Refer to the manufacturer's details before you begin. It is best to apply several thin coats of paint rather than one thick one. To do this, apply the first coat, then leave to dry. Sand lightly and remove any sanding dust with a damp cloth. Repeat to build up several coats of paint.

Old wood If the surface is in poor condition it is best to strip it back to bare wood and then proceed as for new wood. Use a commercial stripper and refer to the manufacturer's instructions.

If the surface is in good condition but you want to change the colour, you should first rub lightly over the entire surface using fine grade steel wool soaked in white spirit. This will remove old wax, grease and dirt. Work in a well ventilated area. Wipe over with a clean cloth to remove any residue. Mix up a 50/50 solution of vinegar and water. Apply this to a clean cloth and wipe down again – this will neutralise the surface. Leave to dry. Sand with fine grade sandpaper, then remove any sanding dust with a damp sponge. The surface can now be basecoated. Proceed in the same way as described for new wood.

New metal Most new metal comes with a rust-protective film of oil. Remove this with soap and water, then wipe down with a 50/50 solution of vinegar and water. Dry thoroughly for at least twenty-four hours, or in a warm oven. Apply a coat of metal primer, following the manufacturer's instructions. Sand with fine grade sandpaper then remove any sanding dust with a damp sponge. The metal is now ready for basecoating. Proceed in the same way as described for new wood.

Old metal Remove old, flaking paint with a paint stripper, following the manufacturer's instructions. Use a wire brush to remove any rust, and to reveal the shiny metal. If the item is very rusty, use a commercial rust treatment, following the manufacturer's instructions. Now apply a coat of metal primer and proceed in the same way as described for new metal.

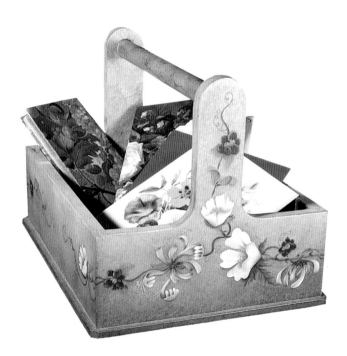

Above and opposite
Both the trug and the picture frame are painted on a sponged background (see pages 14–17). They are then decorated with honeysuckle and dog roses using the side-loading technique (see pages 24–47).

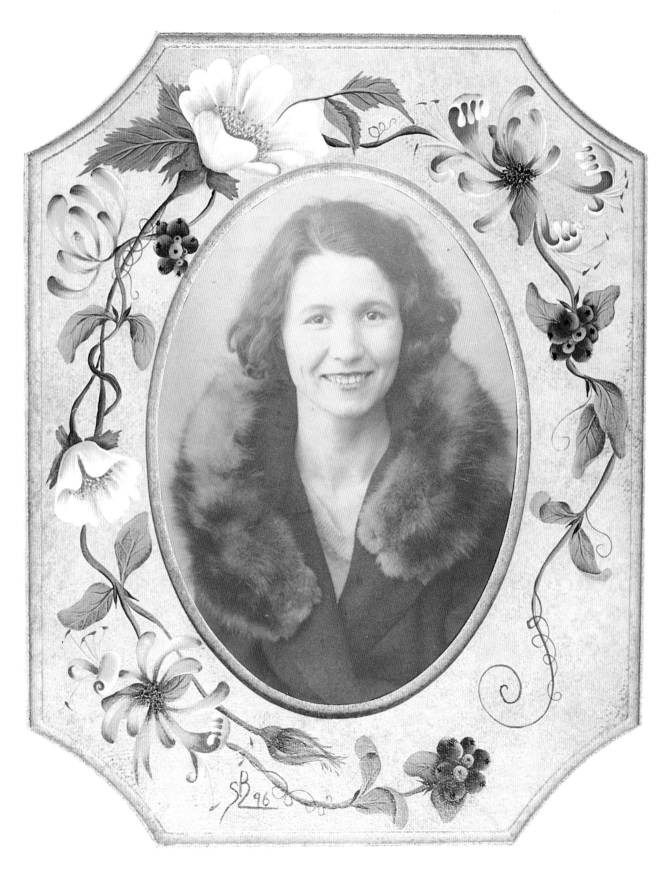

Decorative backgrounds

In this chapter I illustrate how to paint decorative and textured backgrounds that will enhance your painted designs. If you are painting a large piece of furniture for example, you may not want to decorate it with lots of flowers; on the other hand, a flat basecoat could look rather plain on the non-decorated areas. This is where a decorative background is ideal. Dramatic backgrounds can be created with the use of strongly contrasting colours, or subtle shades can be used to produce a more understated effect.

The examples in this chapter are designed to give your project added interest. You can sponge, crackle, texture or marble your surface to complement the painted design. All the techniques are simple and extremely effective.

Sponging ~ *simple sponging*

Gather together a selection of natural and synthetic sponges with different surface textures. Experiment to see which leaves the best imprint, by applying paint and then dabbing on to paper. Some of the synthetic sponges are rather smooth, but you can pinch off small pieces from the surface to create a more interesting print. My favourite sponges are the natural sea sponges. These produce a wonderful effect and, although they tend to be expensive to buy, they will last a long time if properly cared for. Never squeeze a natural sponge when dry; soften it in water first, and always handle it with care. Both natural and synthetic sponges should always be rinsed well immediately after use.

The sponging demonstration opposite consists of five stages. However, you can create a very simple sponged effect by simply following stages 1–3. Extra layers of sponging (stages 4 and 5) will add more depth and interest.

For this technique, you should mix retarder in with the paint that you are using for the topcoat. Retarder slows down the drying time, allowing you more time to move the paint. Choose a topcoat in a contrasting colour to the basecoat.

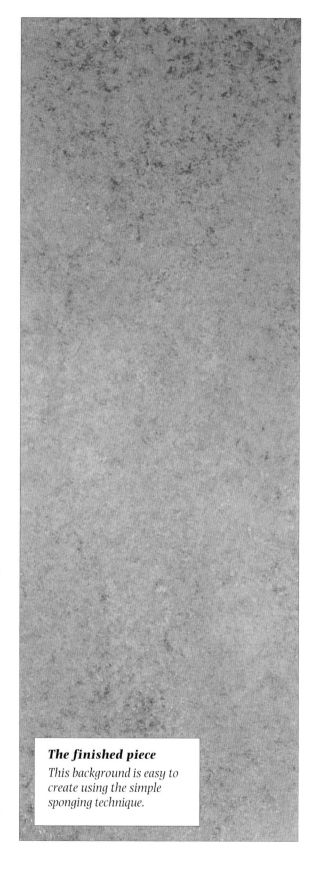

The finished piece
This background is easy to create using the simple sponging technique.

You will need

- retarder
- acrylic paint: red earth; teal green; warm white
- 2.5cm (1in) basecoating brush
- natural sponges: 1 coarse and 1 fine
- absorbent paper

Colour mixing recipes

• LIGHT TEAL

 teal green + warm white (1:3)

• VERY LIGHT TEAL

 teal green + warm white (1:4)

1. Basecoat your surface in red earth (see page 12). Leave to dry.

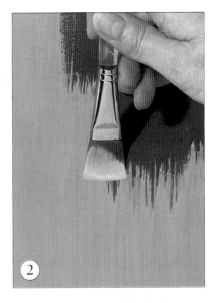

2. Mix light teal with a little retarder. Apply a fairly thin topcoat over the basecoat. Do not worry if the brushstrokes show.

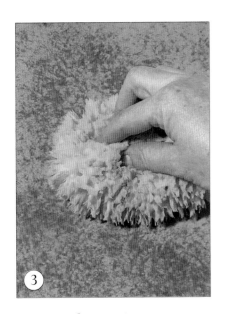

3. Press a damp coarse sponge on to the wet topcoat. Vary the pressure to remove areas of paint and expose the basecoat colour in parts. Leave to dry.

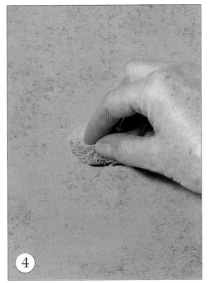

4. Dab a fine sponge on to your palette and pick up some light teal. Remove the excess paint on a piece of absorbent paper. Sponge over the surface to transfer paint back over the topcoat. Repeat with a coarse sponge. Try to cover some areas more than others. Leave to dry.

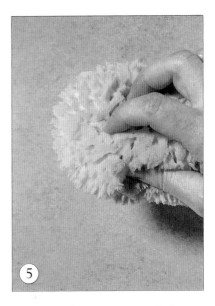

5. Sparingly sponge very light teal over the board using a coarse sponge. Bounce the sponge on to the surface to soften the pattern. Add a little more colour in certain areas to avoid a flat effect.

Sponging ~ *multicoloured sponging*

You will need

- acrylic paint: red earth; teal green; yellow oxide; warm white
- retarder
- 2.5cm (1in) basecoating brush
- natural sponges: 1 coarse and 1 fine
- absorbent paper

Colour mixing recipes

• LIGHT TEAL

teal green + warm white (1:3)

When you are confident about using the simple sponging technique (see page 15), experiment with applying additional colours in patches and blending them with the sponge. Incorporate colours into the background that you intend to use in the main design – this will help integrate the two elements and will create a more harmonious project.

Note

It is not necessary to wash the sponge every time you use a different colour, but you should wipe off excess paint on absorbent paper.

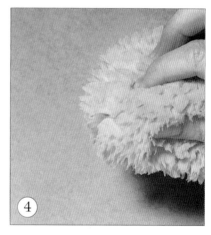

1. Follow steps 1 and 2 on page 15. Use a basecoating brush to add patches of yellow oxide, warm white and teal green while the light teal topcoat is still wet.

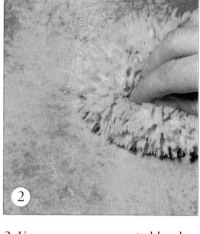

2. Use a coarse sponge to blend the edge of each colour patch. Wipe off excess colour on absorbent paper between sponging each patch. Sponge in between the colours to expose the background colour. Leave to dry.

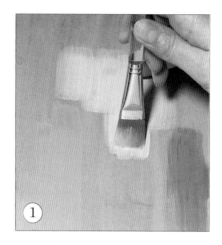

3. Use both a coarse and fine sponge to pat light teal over the entire surface. Bounce the sponges firmly to soften the effect. Reinforce the yellow, white and green areas with a little more colour. Continue sponging until the required effect is achieved. Leave to dry.

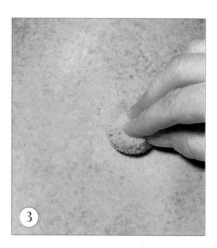

4. Use a fine and coarse sponge to add more colour. Slightly extend each patch, blending it into the neighbouring one while the paint is still wet. Clean the coarse sponge, and then bounce it over the whole surface to soften the effect.

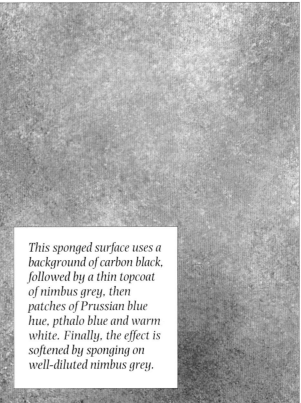

This sponged surface uses a background of carbon black, followed by a thin topcoat of nimbus grey, then patches of Prussian blue hue, pthalo blue and warm white. Finally, the effect is softened by sponging on well-diluted nimbus grey.

The finished piece

This gently gradated effect is created by sponging with several colours.

A dark background can be very effective when oversponged with pale colours. Here, a background of red earth is applied, then a thin topcoat of light grey (nimbus grey + warm white, 1:1) followed by patches of beige (fawn + warm white, 1:1), light yellow (yellow oxide + warm white, ½:1), cream (smoked pearl + warm white, 1:1) and light green (moss green + warm white, 1:1). Finally, the effect is softened by sponging on well-diluted warm white.

Texturing

Textured backgrounds can be achieved using a variety of everyday household items. Look for things that have a bumpy or uneven surface. These can be used to 'print' their pattern into the paint.

For this technique, as with sponging, two contrasting colours are used one on top of the other. When the textured surface is pressed on to the wet topcoat, some of the paint is removed, exposing the background colour. Remember, strongly contrasting colours produce a dramatic effect, while subtle contrasts will give a softer result.

The basic preparation is the same as for sponging (see page 15). You should basecoat your surface, and allow it to dry. Then, apply a thin topcoat which has a little retarder added to it, and proceed as shown in the examples on this page.

Note

Depending on how much water you add to your paint, a different effect will be achieved: a watery consistency will result in a soft, blurred pattern; a thicker consistency will give a sharper, more defined result. Experiment to see which effect you prefer.

Try using a bottle brush to add texture to your background. Press it into the wet topcoat with the flat of your hand. You can alter the angle of the brush to achieve a random pattern.

Newspaper can be used to create a striking pattern. Simply roll a length of twisted paper across the wet topcoat.

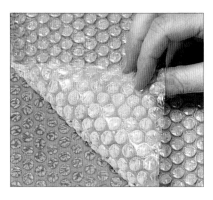

Bubble wrap can be laid over a wet topcoat and pressed evenly over the whole surface. In this example the pattern is very even. If a more random pattern is required, the bubble wrap can be reapplied at a slightly different angle, while the topcoat is still wet.

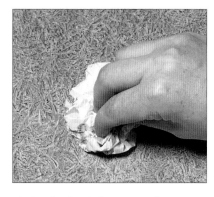

A simple plastic bag can make an effective texturing tool. Cut a square from the bag and then scrunch it up into a pad. Press the pad into the wet topcoat, and move it about to achieve a random pattern.

Try using absorbent paper to create a subtle pattern. Lay the paper over a wet topcoat and cover with a flat object, i.e. a book or a piece of wood. Press the flat object gently, then carefully remove it and the absorbent paper. For this technique it is important not to press the absorbent paper with your fingers or hand as this will leave an uneven imprint.

Crackle finishing

You will need

- acrylic paint: red earth; opal
- crackle medium
- 2.5cm (1in) basecoating brush

This is a technique that results in new paint looking weathered and cracked as if it were aged paint. The effect is achieved by painting a layer of crackle medium (a sticky transparent substance) over a dry basecoated surface, and then applying a topcoat of paint. As the topcoat dries, the crackle medium causes it to crack, and the colour of the basecoat is revealed through these cracks. There are lots of different crackle mediums available; some will produce small cracks, some larger. The finished effect also depends on how thickly you apply the crackle medium. Experiment with different applications to see which effect you prefer.

> **Note**
>
> The consistency and thickness of the topcoat of paint will affect the size of the cracks. The thinner the paint mixture, the finer the cracks; the thicker the paint, the coarser the cracks.

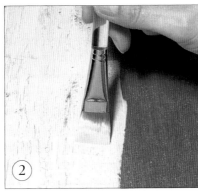

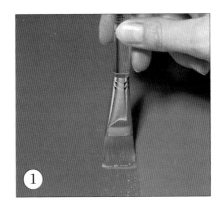

1. Basecoat your surface using red earth (see page 12). Leave to dry. Apply a layer of crackle medium. Do not overbrush. Any brush marks will even out during drying. Allow to dry at room temperature for approximately an hour until slightly tacky.

2. Apply a coat of opal. Do not overbrush once applied. Leave to dry at room temperature, preferably overnight, to allow the cracks to appear.

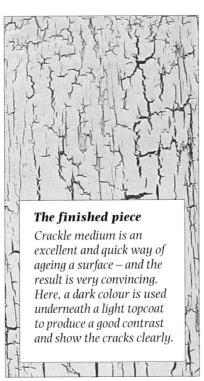

The finished piece
Crackle medium is an excellent and quick way of ageing a surface – and the result is very convincing. Here, a dark colour is used underneath a light topcoat to produce a good contrast and show the cracks clearly.

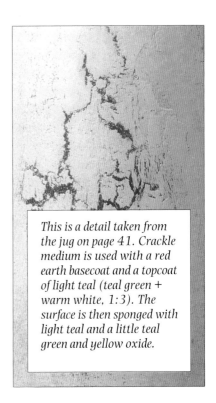

This is a detail taken from the jug on page 41. Crackle medium is used with a red earth basecoat and a topcoat of light teal (teal green + warm white, 1:3). The surface is then sponged with light teal and a little teal green and yellow oxide.

Quick and easy marbling

You will need

- acrylic paint: teal green; smoked pearl
- retarder
- 2.5cm (1in) basecoating brush
- cling film

Colour mixing recipes

- **LIGHT TEAL**
 teal green + smoked pearl (1:3)

You can have great fun with this easy but very effective technique. Experiment to produce different effects: use cling film for a fine veined effect, or a plastic bag for a coarser result; try using a dark colour over a light background, then a light colour over a dark one. If you are creating a background for a painted design, choose subtle colour contrasts to give a soft effect that will not compete with the design itself. Stronger contrasts can be used for an area that will not have additional decoration, such as the inside of a box.

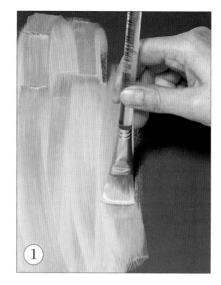

1. Basecoat your surface using teal green (see page 12). Leave to dry. Apply a thin topcoat of light teal mixed with a little retarder.

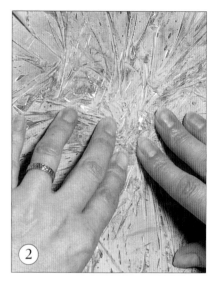

2. Lay cling film over the wet topcoat. Use your fingers to push the cling film into creases, and form a random pattern.

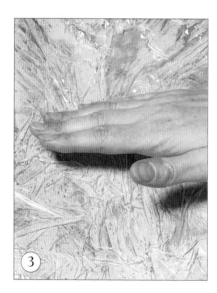

3. Gently rub the flat of your hand across the cling film to force the wet paint into the creases. Be careful not to move the cling film as this will change the pattern.

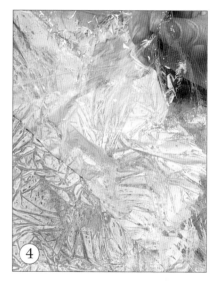

4. Carefully peel off the cling film. Leave to dry.

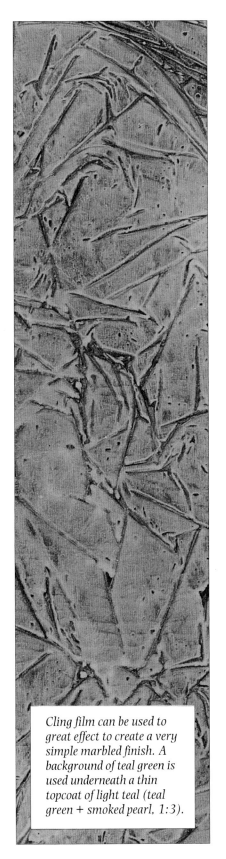

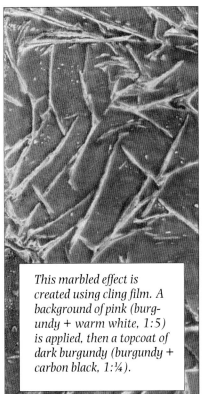

This marbled effect is created using cling film. A background of pink (burgundy + warm white, 1:5) is applied, then a topcoat of dark burgundy (burgundy + carbon black, 1:¼).

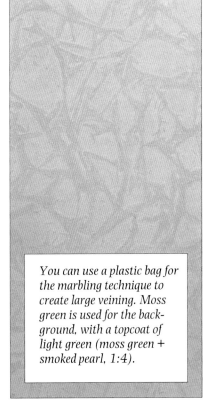

You can use a plastic bag for the marbling technique to create large veining. Moss green is used for the background, with a topcoat of light green (moss green + smoked pearl, 1:4).

Cling film can be used to great effect to create a very simple marbled finish. A background of teal green is used underneath a thin topcoat of light teal (teal green + smoked pearl, 1:3).

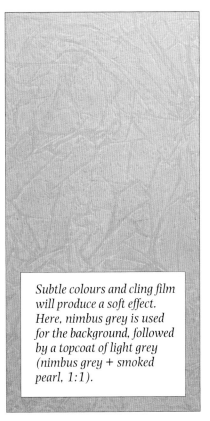

Subtle colours and cling film will produce a soft effect. Here, nimbus grey is used for the background, followed by a topcoat of light grey (nimbus grey + smoked pearl, 1:1).

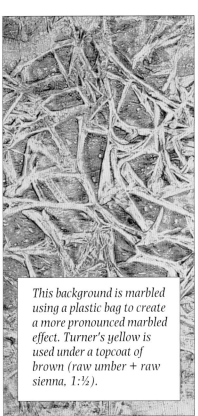

This background is marbled using a plastic bag to create a more pronounced marbled effect. Turner's yellow is used under a topcoat of brown (raw umber + raw sienna, 1:½).

Realistic marbling

You will need

- acrylic paint: carbon black; nimbus grey; warm white; burgundy
- chalk pencil or watercolour crayon
- liner brush
- mop brush
- retarder
- 2.5cm (1in) basecoating brush
- natural sponges: 1 coarse, 1 fine

Colours mixing recipes

• **DARK BURGUNDY**

 burgundy + a touch of carbon black

Look at examples of real marble before you start this technique. In particular, study how the veins relate to one another, then make sketches of these vein patterns, which you can refer to.

1. Use the multicoloured sponging technique (see page 16) to cover your surface. For this example, I have used a carbon black background then added a topcoat of nimbus grey, with patches of warm white and dark burgundy. Leave to dry, then mark in the veins with a chalk pencil or a watercolour crayon.

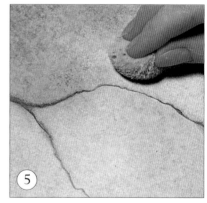

2. Use a liner brush to apply fine lines of dark burgundy mixed with a few drops of retarder. Work a short length at a time, painting slightly to one side of the chalk line so that it can be erased easily. Commence the lines using the tip of the brush, increasing the downward pressure now and again to create lines of varying thickness.

3. Every so often, stop and soften the lines with a mop brush while the paint is still wet. Use varying pressure when brushing the mop across the lines, to again create lines of an uneven thickness.

4. Add a few warm white highlights on one side of the dark lines using a liner brush. Paint short lengths at a time, blending with a mop brush away from the dark lines as you work.

5. Reinforce and sharpen up the dark lines here and there using carbon black and a liner brush. Soften with a mop brush. Use a fine sponge to pick up more of the background colours and enhance areas close to the veins.

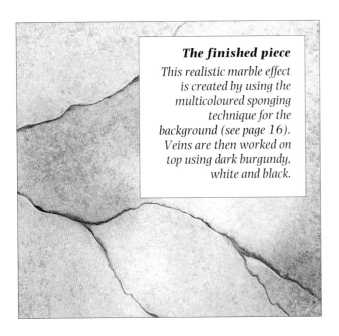

The finished piece

This realistic marble effect is created by using the multicoloured sponging technique for the background (see page 16). Veins are then worked on top using dark burgundy, white and black.

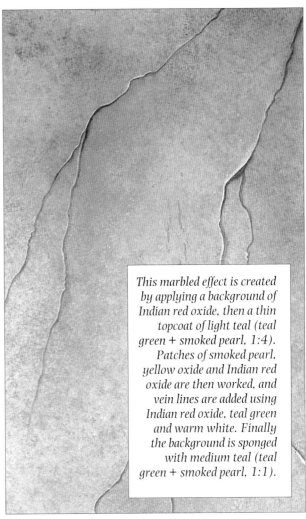

This marbled effect is created by applying a background of Indian red oxide, then a thin topcoat of light teal (teal green + smoked pearl, 1:4). Patches of smoked pearl, yellow oxide and Indian red oxide are then worked, and vein lines are added using Indian red oxide, teal green and warm white. Finally the background is sponged with medium teal (teal green + smoked pearl, 1:1).

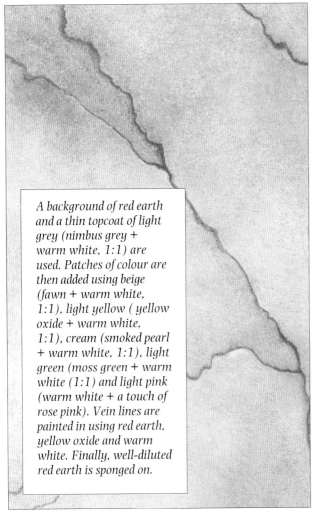

A background of red earth and a thin topcoat of light grey (nimbus grey + warm white, 1:1) are used. Patches of colour are then added using beige (fawn + warm white, 1:1), light yellow (yellow oxide + warm white, 1:1), cream (smoked pearl + warm white, 1:1), light green (moss green + warm white (1:1) and light pink (warm white + a touch of rose pink). Vein lines are painted in using red earth, yellow oxide and warm white. Finally, well-diluted red earth is sponged on.

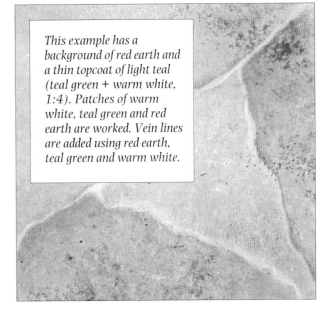

This example has a background of red earth and a thin topcoat of light teal (teal green + warm white, 1:4). Patches of warm white, teal green and red earth are worked. Vein lines are added using red earth, teal green and warm white.

Side-loading technique

The side-loading technique involves working with a flat brush that has solid colour on one side, which gradually fades out to no colour on the other side. The process of blending paint across the brush can be greatly helped with the addition of a few drops of extender (sometimes referred to as flow medium) to the brush. Extender thins the viscosity of acrylic paint, enabling you to blend the paint across the brush more easily, and paint a longer stroke before running out of colour – once you have tried it, you will not want to paint without it!

I would suggest that you first practice this technique using a No. 8 flat brush, before trying a smaller No. 6 brush.

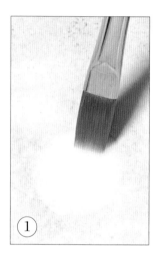

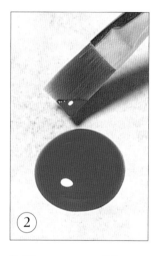

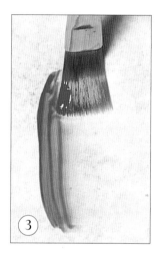

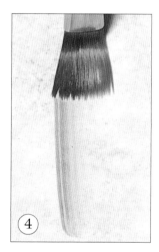

1. Pick up a little extender on a flat brush, and work it evenly into the bristles.

2. Dip a corner of the damp brush into a paint pool, to pick up a little paint.

3. Stroke the brush backwards and forwards along a 4cm (1½in) strip on a ceramic tile or blending palette. Apply slight downward pressure to the hairs of the brush on each stroke. Work in the same spot and use both sides of the brush to avoid paint building up on the top edge. Keep blending in this way until you can see that paint has spread three-quarters of the way across the brush.

4. Apply the brush to your painting surface. Keep the whole width of the brush in contact with the surface as you stroke the colour on, applying slight downward pressure. The finished effect should be a gradated colour with a sharp edge on one side, fading gradually to no colour at all.

Note

You may need to pick up more paint as you blend the paint across the brush. If you do, keep the clean side of your brush out of the paint.

If the brush feels as if it is dragging, pick up a drop of extender on the clean corner of the brush and continue to blend.

Water can be used instead of extender for this technique, but it is not as easy to use.

Photograph album

This album features an Australian flower design of flannel flowers, bottle brush and wattle blossom. Turner's yellow is used for the background of the crackle finish, with a topcoat of raw umber. The surface is sponged with burnt sienna, raw umber, raw sienna, burgundy and rich gold. The lace border is painted using the side-loading technique.

Lace is a good way of practising your side-loading technique (see page 33).

Leaves

Most designs contain more leaves than flowers, but these are rarely the focal point of a design. You should not, therefore, paint leaves with very bright colours as you want them to enhance and frame the main design, not dominate it. If you are painting a cluster of leaves, try to avoid painting them all in exactly the same way: vary the colour, size and shape; overlap some leaves and curl the edges of others to create a more natural design.

Here, I have painted a very simple leaf shape, but any leaf can be painted using this technique. I have used a No. 8 flat brush unless otherwise specified.

Flat leaf

1. Basecoat the leaf shape using medium green. Leave to dry. Mark in the central vein line with a chalk pencil.

2. Side-load the flat brush with moss green and use this to add a highlight along the central vein. Make sure the sharp edge is touching the vein line. Add another highlight to the top edge of the leaf.

3. Use pine green to add shading to the other side of the central vein and along the bottom edge of the leaf.

4. Paint the smaller veins in moss green with the tip of a liner brush.

You will need

- acrylic paint: pine green; moss green; warm white
- No. 8 flat brush
- liner brush
- chalk pencil
- extender

Colour mixing recipes

• **MEDIUM GREEN**

 pine green + a touch of warm white

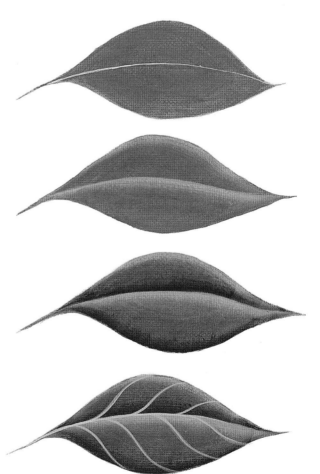

26

Curling leaf

1. Basecoat the leaf shape using medium green. Leave to dry, then mark in the central vein and the leaf turnover lines with a chalk pencil.

2. Add moss green highlights with a side-loaded flat brush.

3. Add shading using pine green. Note that the sharp edge of the shading should touch the sharp edge of the highlight.

4. Paint the veins in moss green with the tip of a liner brush.

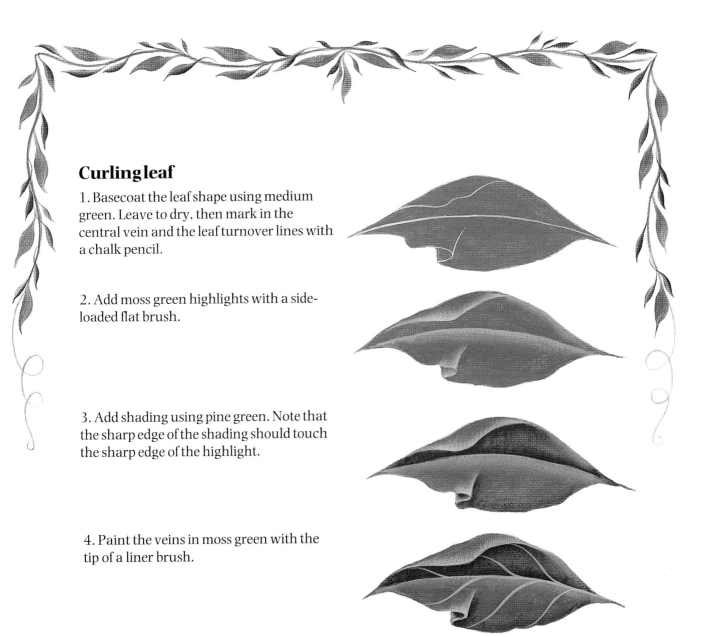

Note

When applying highlights and shading to create a three-dimensional effect, remember that the sharp edge of the highlight and the sharp edge of the shading should touch.

Flowers

Side-loading is a versatile technique that can be applied to all flowers to add depth and realism. The following demonstration shows how to create a three-dimensional flower from a flat basecoated shape, using the side-loading technique to add shading and highlights. Use a No. 8 flat brush unless otherwise specified.

This demonstration has been worked on a background marbled with a plastic bag (see pages 20–21). Nimbus grey was used as a basecoat, with light grey on top.

You will need

- acrylic paint: nimbus grey; warm white; Turner's yellow; burnt sienna; pine green; moss green
- extender
- plastic bag
- basecoating brush
- No. 8 flat brush
- liner brush
- stipple brush
- cocktail stick

Colour mixing recipes

- **LIGHT GREY**

 nimbus grey + warm white (1:1)

- **MEDIUM GREEN**

 pine green + a touch of warm white

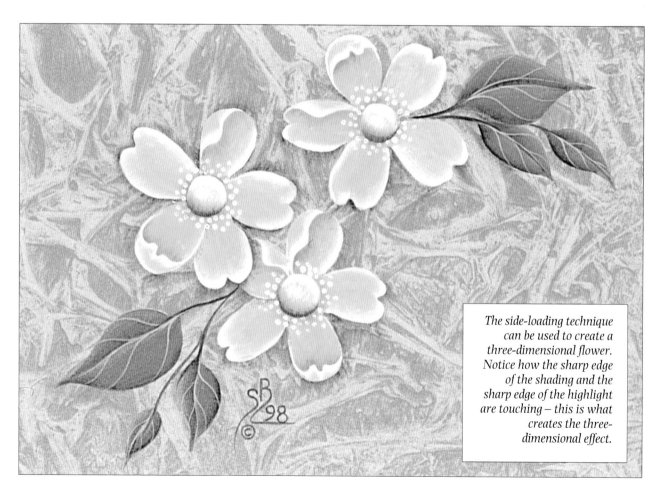

The side-loading technique can be used to create a three-dimensional flower. Notice how the sharp edge of the shading and the sharp edge of the highlight are touching – this is what creates the three-dimensional effect.

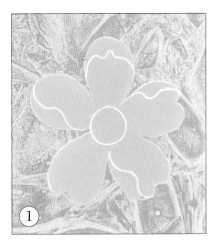

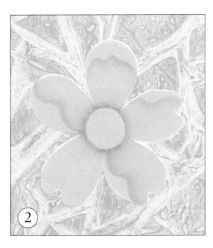

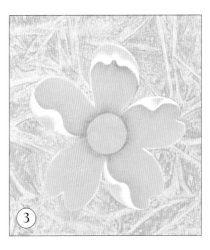

1. Basecoat the shape of the flower using Turner's yellow. Depending on the flower you are painting, apply the central lines and turnover petal lines using the method described on page 31.

2. Apply shading using the flat brush side-loaded with burnt sienna.

3. Highlight the curled petals in warm white using a side-loaded flat brush. Note that the sharp edge of white should touch the sharp edge of the shading.

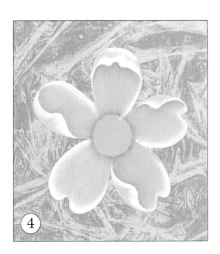

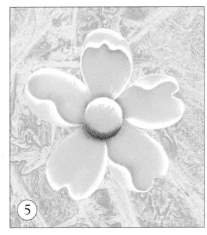

4. Apply highlights to the edges of the other petals using warm white. Enhance the yellow centre with a further coat of Turner's yellow.

5. Apply shading to the bottom half of the centre circle using burnt sienna. Highlight the top half in warm white.

6. Use a cocktail stick and warm white to apply the dots for the stamen. This technique will create a dot with a hole in the centre, which gives a softer effect than a solid dot. Finally, apply a tiny amount of warm white to a dry stipple brush, and stroke the paint lightly on to the centre to add a highlight.

Pansies

The pansy is a nineteenth-century creation, developed from the wild flower *viola tricolor.* These multicoloured flowers were initially very popular with the Victorians but they have remained popular ever since. A huge variety of colour combinations and petal markings are available now, so there are plenty of pansies to choose from.

This project features the side-loading technique shown on page 24. The design looks equally good if you substitute or combine other colours, as shown on page 35.

Although the main flowers that feature in my designs are of a realistic nature, here, the additional flowers (referred to as 'fill-ins') are flowers that I have invented. I have used trumpet- and star-type fill-in flowers, but these could be substituted with any of the other fill-in flowers shown elsewhere in this book. You can buy brushes with blunt or sawn-off handles; if you have one of these, use it when painting the circle for the star flower in stage 5.

For this project, a No. 8 flat brush is used unless otherwise specified.

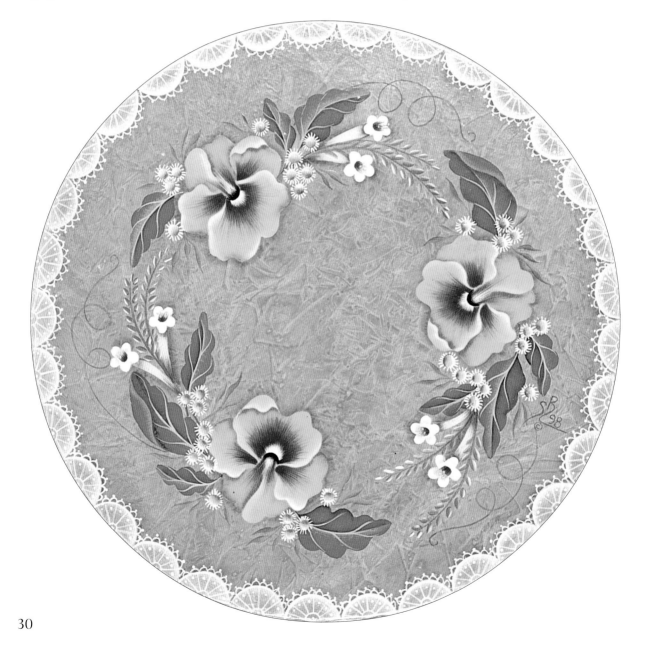

You will need

- acrylic paints: provincial beige; warm white; Turner's yellow; gold oxide; Norwegian orange; brown earth; carbon black; moss green; pine green; smoked pearl; aqua; yellow light; burnt sienna
- No. 8 flat brush
- No. 1 round brush
- liner brush
- stipple brush
- basecoating brush
- retarder
- extender
- cling film
- chalk pencil
- stylus
- masking tape
- transfer paper
- tracing paper
- soft pencil or felt-tip pen

Colour mixing recipes

- **LIGHT BEIGE**

 provincial beige + warm white (1:1)

- **MEDIUM GREEN**

 pine green + a touch of warm white

- **LIGHT YELLOW**

 Turner's yellow + warm white (1:1)

- **BROWN**

 brown earth + Norwegian orange (1:1)

Creating the background

Basecoat your surface using light beige (see page 12). Allow to dry then texture the surface using the quick and easy marbling method (see page 20) and provincial beige as the topcoat.

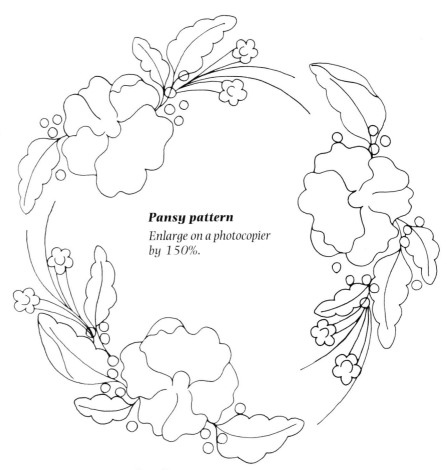

Pansy pattern
Enlarge on a photocopier by 150%.

Transferring the design

I have used a dark background for this project, so it is best to use white transfer paper; if you are using a light background colour, use dark transfer paper. The transfer line is a guide to follow when painting your design. After the painting has been completed, any remaining transfer line can easily be removed using an eraser.

Stage 1
1. Trace the outline of the design on to tracing paper.

Stage 2
2. Use masking tape to secure one edge of the traced design over the background, then insert transfer paper under the tracing. Go back over the outline of the design with a stylus.

Stage 3
3. Lift the paper to check that the design has been transferred.

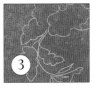
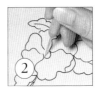

31

Painting the design

Stage 1

Pansy: Apply a basecoat in Turner's yellow. Allow to dry. Reposition the tracing of the design over the flower. Insert transfer paper underneath the tracing, then use a stylus to re-trace the internal petal lines and transfer them back on to the painted flowers.

Leaves: Apply a basecoat in medium green. Leave to dry before transferring the internal lines over the painted image (see above).

Fill-in trumpet flower: Apply a basecoat in light yellow. Shade brown behind the petals, and at the base of the trumpet.

Stage 2

Pansy: Shade in gold oxide behind the petals and highlight in light yellow on the front tips of the petals.

Leaves: Use pine green to add shading, and moss green to add highlights.

Fill-in trumpet flower: Side-load a flat brush with Norwegian orange. Paint a C-stroke into the throat of the flower. To do this, imagine you are painting the letter 'C' with the sharp edge of the flat brush – keep the full width of the brush in contact with the surface as you work.

Stage 3

Pansy: Reinforce the shading in some areas using Norwegian orange, and highlight here and there with yellow light. Use a liner brush and Norwegian orange to paint the starburst from the centre outwards.

Leaves: Paint the veins in moss green using a liner brush.

Fill-in trumpet flower: Paint a C-stroke around the outside edge of each petal using warm white.

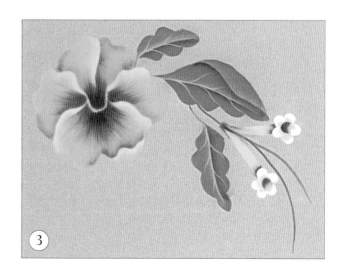

Stage 4

Pansy: Add liner brush work over the Norwegian orange starburst using brown earth. Work from the centre outwards, and use short strokes. Add a short fringe in warm white. Use carbon black and a side-loaded flat brush to paint a C-stroke into the throat of the flower. Extend the inside curve of the C-stroke using a liner brush and a few black lines.

Stage 5

Pansy: Sharpen up the shading using brown earth.

Leaves: Add more shadows on one side of the veins using pine green. Stipple on a little aqua here and there (see page 44). Paint in the central veins of the small fern-like leaves with a liner brush and medium green. Dab on tiny leaves along each side of these veins using a No. 1 round brush and medium green. Add warm white highlights.

Fill-in trumpet flower: Paint a strong highlight around the base of the throat in warm white. Add the stamen using a liner brush and brown earth and use yellow light and a stylus for the dots. Use a liner brush and Norwegian orange to reinforce the shading at the base of the trumpet.

Stage 6

Fill-in star flower: Add little clusters of star flowers around the design. Paint circles in Turner's yellow. Use the tip of a liner brush and warm white to paint short lines radiating out from each centre circle. Paint C-strokes in burnt sienna around the bottom half of each circle. Paint C-strokes in warm white around the top half of each circle.

Stage 7

Lace: Mark out the scallops with a chalk pencil. Use warm white to apply a side-loaded stroke inside each scallop with the sharp edge following the outside curve. Apply additional pattern lines with the tip of a liner brush, and use a stylus to apply dots.

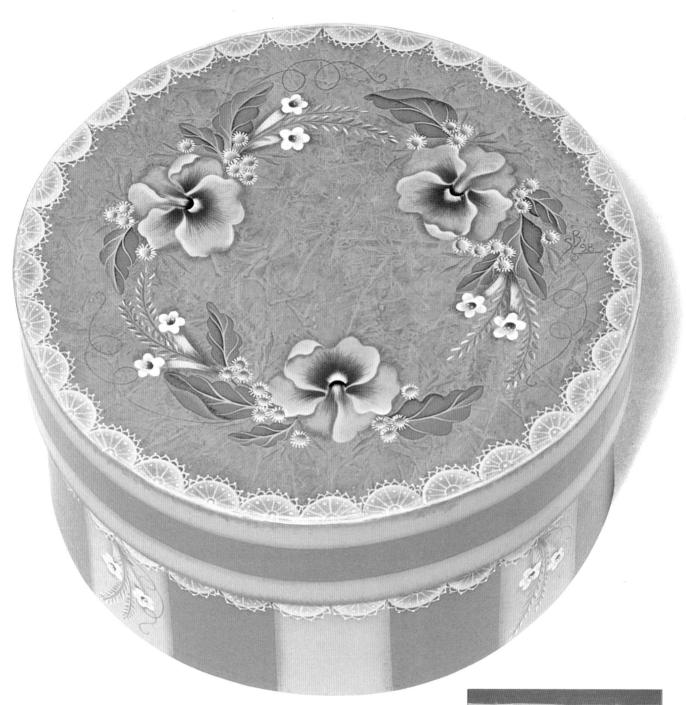

Pansy hat box

The pansy design works well on a round object. For this hat box I used masking tape to mask off stripes around the outside of the box and the rim of the lid, and then I painted the unmasked areas in provincial beige. I used a No. 8 side-loaded flat brush and provincial beige to paint shadows along the sides of the darker stripes. The detail opposite shows how the delicate trumpet flowers are complemented by the pretty lace design. Notice the shading along the dark stripes around the box, which softens the harsh edges.

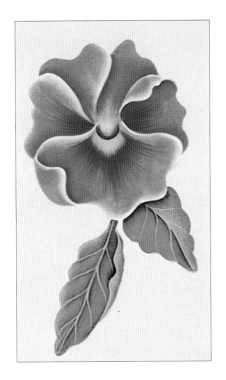

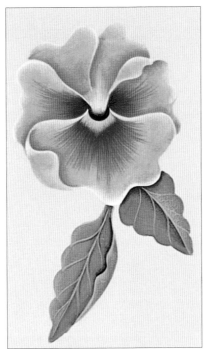

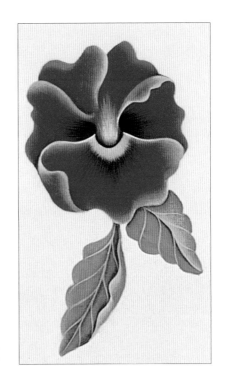

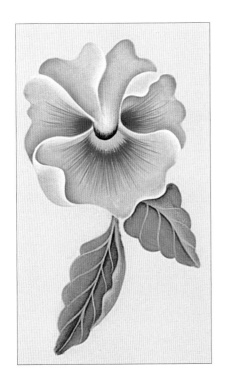

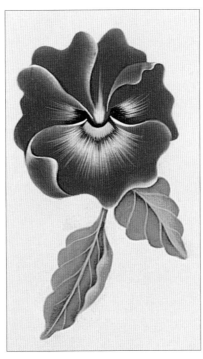

You can alter your colours to produce a stunning array of realistic pansies. The colours used for these five pansies are:

lilac pansy: lilac (dioxide purple + warm white, 1:2), dioxide purple, warm white and yellow light

pink pansy: pink (transparent magenta + warm white, 1:4), transparent magenta, Payne's grey, yellow light, carbon black and warm white

red pansy: napthol crimson, napthol red light, vermillion, yellow light, warm white and carbon black

pale blue pansy: blue (ultramarine + warm white, 1:4), ultramarine, pthalo blue, warm white and yellow light

purple pansy: dioxide purple, carbon black, warm white and yellow light

35

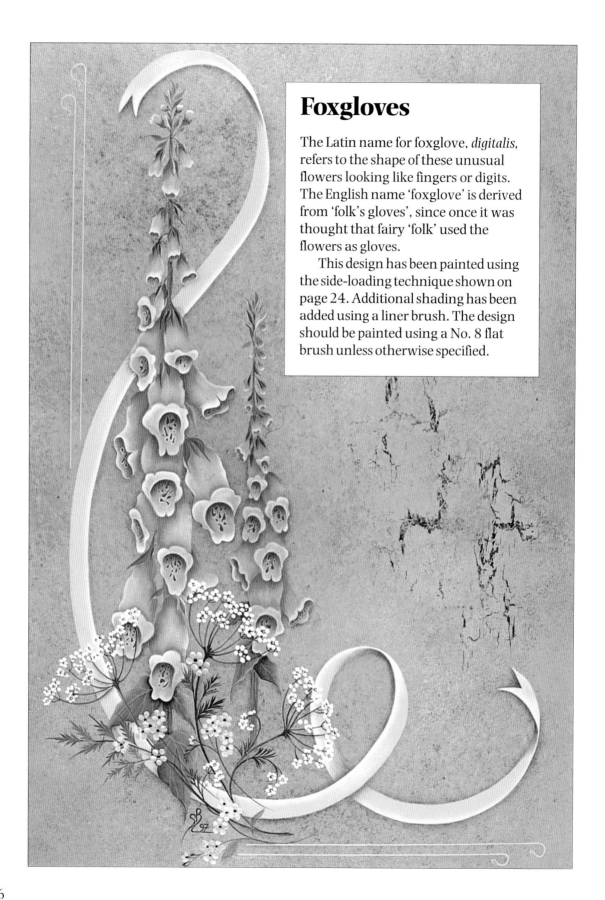

Foxgloves

The Latin name for foxglove, *digitalis*, refers to the shape of these unusual flowers looking like fingers or digits. The English name 'foxglove' is derived from 'folk's gloves', since once it was thought that fairy 'folk' used the flowers as gloves.

This design has been painted using the side-loading technique shown on page 24. Additional shading has been added using a liner brush. The design should be painted using a No. 8 flat brush unless otherwise specified.

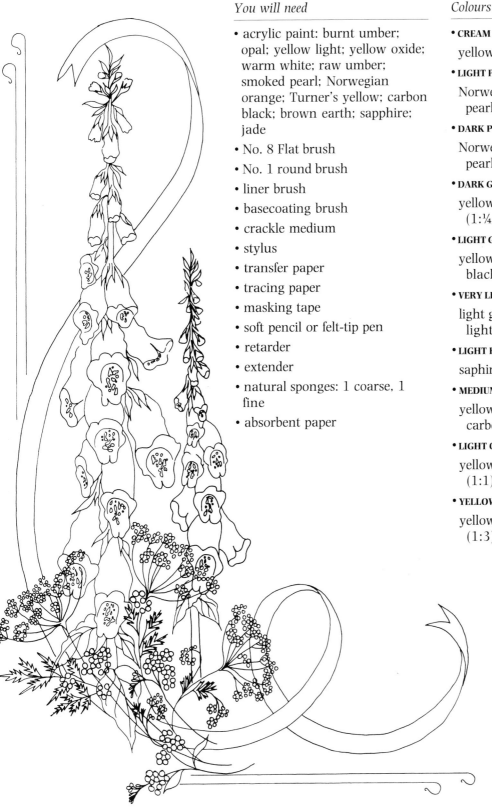

You will need

- acrylic paint: burnt umber; opal; yellow light; yellow oxide; warm white; raw umber; smoked pearl; Norwegian orange; Turner's yellow; carbon black; brown earth; sapphire; jade
- No. 8 Flat brush
- No. 1 round brush
- liner brush
- basecoating brush
- crackle medium
- stylus
- transfer paper
- tracing paper
- masking tape
- soft pencil or felt-tip pen
- retarder
- extender
- natural sponges: 1 coarse, 1 fine
- absorbent paper

Colours mixing recipes

- **CREAM**

 yellow light + opal (1:4)

- **LIGHT PEACH**

 Norwegian orange + smoked pearl (1:6)

- **DARK PEACH**

 Norwegian orange + smoked pearl (1:2)

- **DARK GREEN**

 yellow light + carbon black (1:¼)

- **LIGHT GREEN**

 yellow light + a touch of carbon black

- **VERY LIGHT GREEN**

 light green + a touch of yellow light

- **LIGHT BLUE**

 saphire + warm white (1:3)

- **MEDIUM OLIVE**

 yellow light + smoked pearl + carbon black (1:2:¼)

- **LIGHT OLIVE**

 yellow light + smoked pearl (1:1) + a touch of carbon black

- **YELLOW**

 yellow oxide + smoked pearl (1:3)

Foxglove pattern

Enlarge on a photocopier by 200%.

Creating the background

Basecoat your surface using burnt umber (see page 12). Paint on patches of crackle medium here and there (see page 19), avoiding the area where the design will be painted. Use the multicoloured sponging technique shown on page 16 to apply a topcoat of medium olive. Add patches of light olive, jade and yellow. Finally, sponge into the background here and there using a small amount of light peach.

Leave to dry, then transfer the ribbon pattern on to the background (see page 31).

Painting the design

Stage 1
Ribbon: Apply a basecoat of cream. Highlight one edge of the ribbon in warm white. Remember that where the ribbon twists, the edge which is to be highlighted changes. Shade into the twist of the ribbon with raw umber. Use the tip of a liner brush to apply more shading and highlights. Work in very fine lines of varying lengths. Leave to dry, then transfer the rest of the foxglove design.

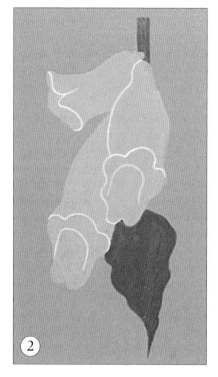

Stage 2
Foxgloves: Apply a basecoat of light peach. Leave to dry then transfer the internal petal lines on to the painted surface.

Leaves: Apply a basecoat of light green.

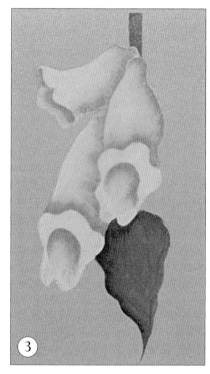

Stage 3
Foxgloves: Shade dark peach into the petals.

Leaves: Shade dark green into the leaves.

Stage 4

Foxgloves: Highlight the petals in warm white.

Leaves: Highlight the leaves in yellow light.

Stage 5

Foxglove: Hold a liner brush upright and use the very tip of it to add dark peach shading. Try to use very fine lines of varying lengths. Slightly extend the first layer of shading.

Leaves: Add more shading in dark green – use a liner brush and the same technique as for the foxglove shading to do this.

Stage 6

Foxglove: Use Norwegian orange and a liner brush to paint small irregular shapes into the throat of each flower. Leave to dry then outline these shapes in warm white.

Leaves: Use a liner brush and very light green to paint in the veins.

Stage 7

Foxglove: Shade into the throat with raw umber. Add more shading here and there using raw umber and a liner brush – use the same technique as in stage 5 to do this.

Leaves: Use a liner brush to paint a dark green line to one side of each of the light green veins – this will create shading.

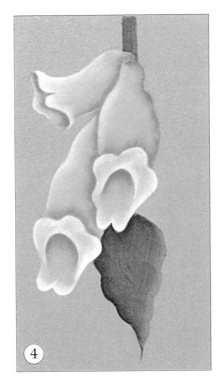

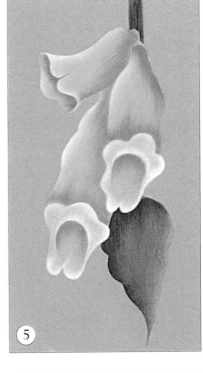

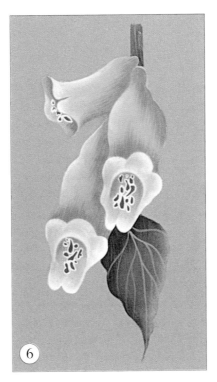

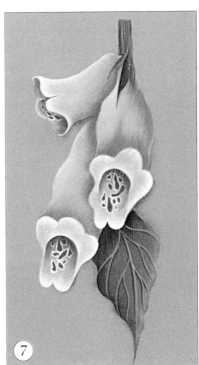

Stage 8

Blue fill-in flowers: Pick up blobs of light blue and white together on the tip of a No. 1 round brush. Pat the brush on to the background to create clusters of petals. Leave a space in the centre of each cluster. Paint the stems in dark green.

White fill-in flowers: Use the same technique as for the blue fill-in flowers, but use warm white only. Paint the stems in dark green.

Stage 9

Blue fill-in flowers: Use a stylus to apply a dot of Turner's yellow to the centre of each flower. Paint the leaves in dark green.

White fill-in flowers: Apply a dot of brown earth to the centre of each flower using a stylus. Paint the leaves in dark green.

Stage 10

Blue fill-in flowers: Use a stylus to add a tiny dot of black to the centre of each flower.

White fill-in flowers: Use a stylus to add a tiny dot of yellow light to the centre of each flower.

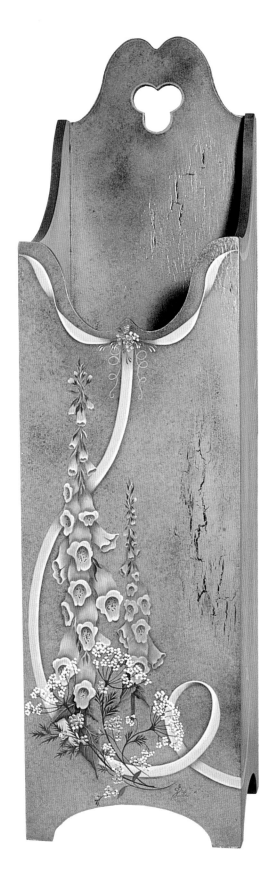

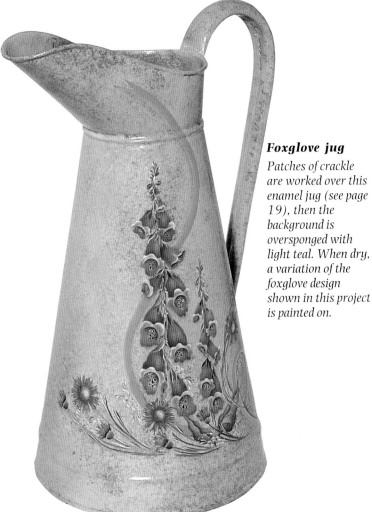

Foxglove jug

Patches of crackle are worked over this enamel jug (see page 19), then the background is oversponged with light teal. When dry, a variation of the foxglove design shown in this project is painted on.

Door finger plate

You can simplify the foxglove design and work it on a smaller object. Here, the background is a flat coat of warm white, and the edging is worked with a side-loaded brush.

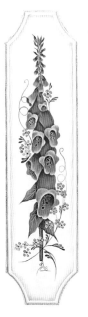

Opposite
Umbrella stand

Here, I have adapted the design given in the project by extending the ribbon and including a small floral detail. Once you are confident with the basic techniques, you can customize designs to suit the shape of the item you are decorating.

Poppies

Poppies have long been a favourite subject for artists; the French artist, Monet, is particularly renowned for painting them.

This design has been painted mainly using the side-loading technique shown on page 24.

Additional shading and highlights have been added to the flowers using a liner brush, and sponging and stippling techniques have been used for the view.

You should use a No. 8 flat brush for this project unless otherwise specified.

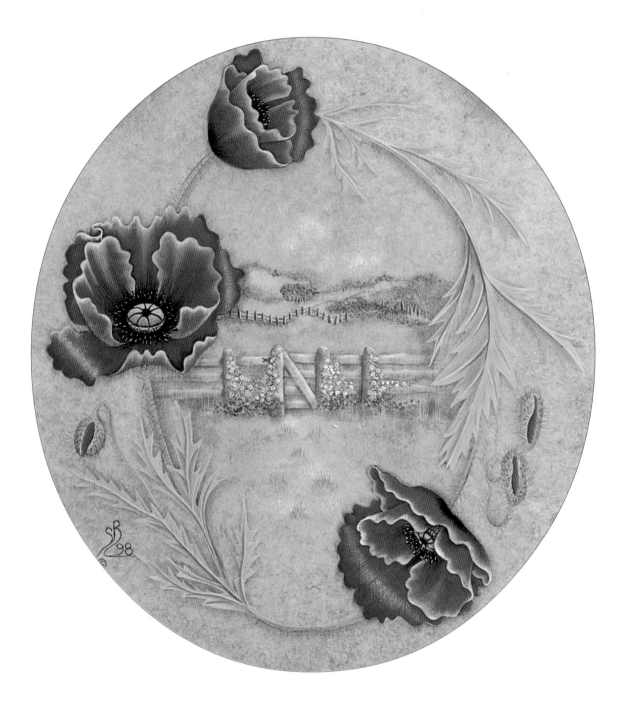

You will need

- acrylic paint: teal green; napthol red light; brown earth; smoked pearl; Turner's yellow; warm white; Payne's grey; yellow light; brilliant green; raw umber; ultramarine; opal
- No. 8 flat brush
- No. 1 round brush
- liner brush
- stipple brush
- basecoating brush
- cocktail stick
- transfer paper
- masking tape
- stylus
- tracing paper
- soft pencil or felt-tip
- retarder
- extender
- natural sponge: 1 fine, 1 coarse
- absorbent paper

Colour mixing recipes

• LIGHT TEAL

teal green + smoked pearl (1:4)

• DARK RED

napthol red light + brown earth + smoked pearl (3:1:1)

• VERY DARK RED

dark red + a touch of Payne's grey

• MEDIUM RED

dark red + smoked pearl + Turner's yellow (1:$^1/_3$:$^1/_2$)

• LIGHT RED

medium red + warm white (1:$^1/_2$) + a touch of Turner's yellow

• DARK GREEN

brilliant green + smoked pearl + brown earth (2:2:3)

• MEDIUM GREEN

dark green + smoked pearl (1:1)

• LIGHT GREEN

medium green + a touch of yellow light

• VERY LIGHT GREEN

light green + a touch of warm white

• BLUE

ultramarine + warm white (1:4)

• LIGHT OPAL

opal + warm white (1:1)

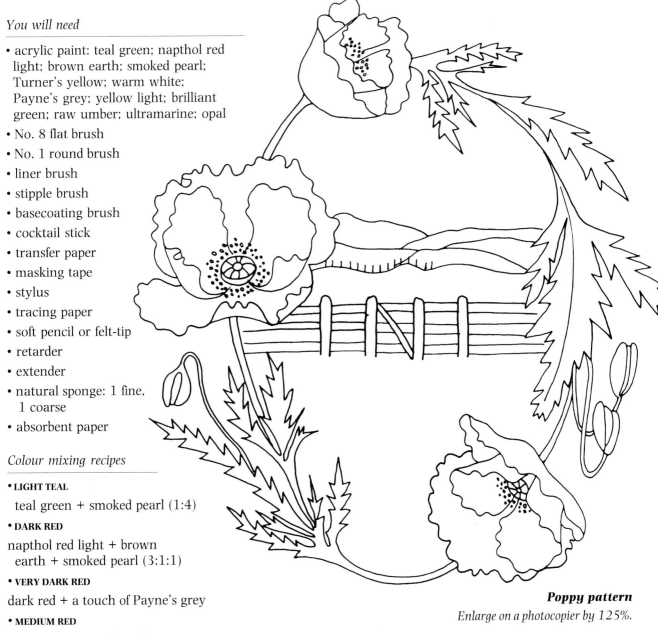

Poppy pattern
Enlarge on a photocopier by 125%.

Creating the background

Basecoat your surface using teal green (see page 12). Use the multicoloured sponging technique shown on page 16 to apply a topcoat of light teal, and then patches of smoked pearl and Turner's yellow. Leave to dry, then transfer the design on to the surface (see page 31).

Painting the design

Stage 1

View: Use a damp fine sponge to apply medium green over the fields and hills, and use blue over the sky area.

Leaves: Apply a basecoat of light green to the leaves and stems using a No. 1 round brush.

Poppies: Apply a basecoat of dark red to the petals. Leave to dry before transferring the internal petal lines on to the painted surface.

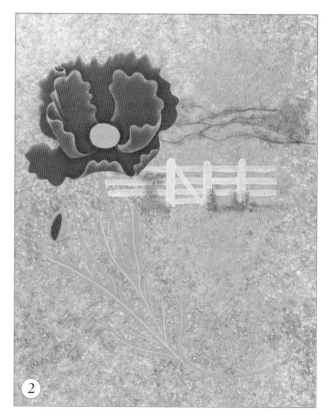

Stage 2

View: Paint the hill contours using a liner brush and dark green. Apply a basecoat of opal to the fence. Stipple in some indication of foliage along the hill contours and around the base of the fence using medium green. To do this, pick up a small amount of paint on a dry stipple brush, then dab the brush on to absorbent paper to remove most of the paint. Hold the brush upright, then bounce it up and down, depositing paint where required. Repeat, until the required effect is achieved.

Leaves: Paint in the central veins using a liner brush and very light green.

Poppies: Paint the flower centres in light green using a No. 1 round brush. Shade the petals with very dark red, then add highlights in light red.

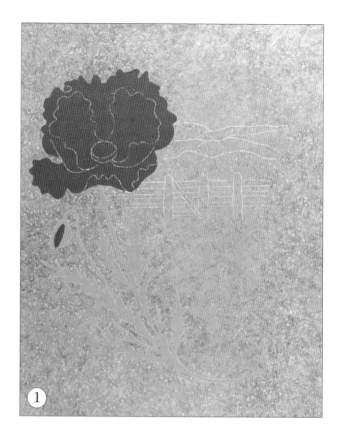

Stage 3

View: Add shading to the fence using raw umber, then highlight with light opal. Paint the distant fence with a liner brush and raw umber. Highlight the sides of the posts with a liner brush and opal. Use a dry stipple brush and opal to indicate a worn path, then repeat with light opal. Stipple light and dark green here and there over the fields.

Leaves: Shade one side of the central veins in a medium green and highlight the other side in very light green.

Poppies: Add dark green shading to the flower centres, and use yellow light for highlighting. Use warm white to add more highlighting to the edges of the petals. Use the tip of a liner brush and yellow light to paint very fine lines on the petals; this will create highlights. Side-load a flat brush with napthol red light and apply this where the petals curl backwards and therefore are not highlighted on the edges. Create shading by adding very fine black lines made with a liner brush; these should radiate from the centre.

45

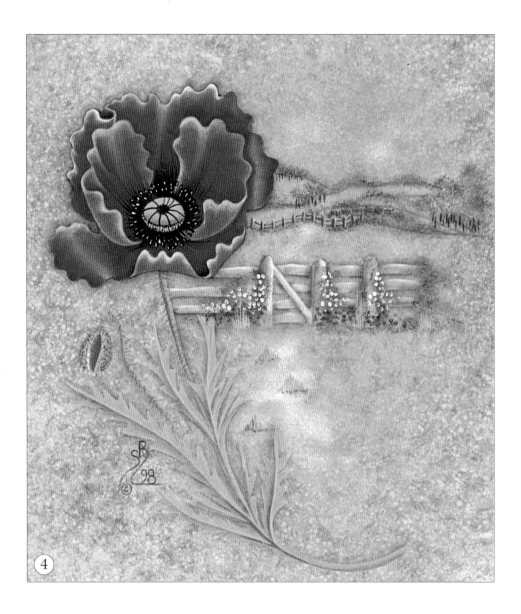

Stage 4

View: Use dark green to shade the background around the main fence. Paint tree trunks on the distant trees using a liner brush and raw umber, and stipple in additional foliage around the main fence. Use the tip of a cocktail stick to paint in white and red flowers in front of the fence. Use the tip of a liner brush to dot in poppies in the distant field. Paint clumps of grass along the path and around the main fence using a liner brush and dark green. Finally, stipple a few highlights in the grass and foliage using yellow light.

Leaves: Re-paint the central veins in a very light green using a liner brush. Shade around the outside of the leaves using teal green. Paint random spiky hairs along the stems and around the outside of the buds using a liner brush and dark green.

Poppies: Repeat the liner work in stage 3, to build up shading and highlights. Vary the length of the fine lines. Paint a black dot in the centre of two of the flowers. Use a liner brush to add short fine lines radiating out from the centres. Use a liner brush to paint the stamen, radiating from the outside edge of each flower centre. Apply small black spots of varying sizes over the stamen lines. Highlight one side of each black spot in warm white, using the tip of a liner brush. Finally, shade around the outside of the flowers in teal green.

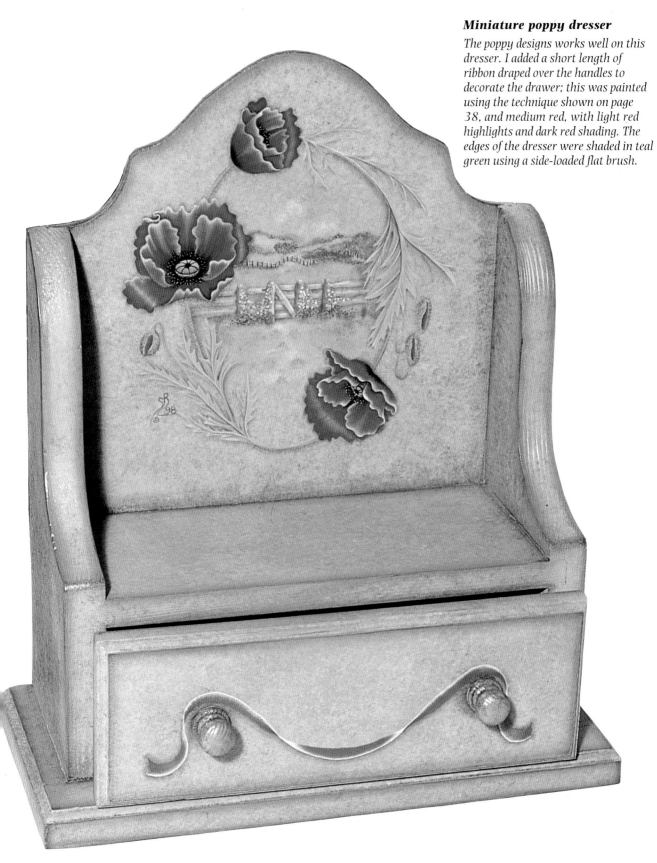

Miniature poppy dresser

The poppy designs works well on this dresser. I added a short length of ribbon draped over the handles to decorate the drawer; this was painted using the technique shown on page 38, and medium red, with light red highlights and dark red shading. The edges of the dresser were shaded in teal green using a side-loaded flat brush.

Pat-blending technique

Pat-blending produces a similar result to that of side-loading and again, the colour is used over a flat background. The added advantage of this technique is that several colours can be blended together to create lovely effects.

In the example shown here, I have only used two colours to demonstrate this technique. It is best to experiment with two colours to start with, then apply additional colours as your confidence grows. This technique does require practice, so do not give up too easily.

Pat-blending is worked over a dry basecoat. Retarder is used under the topcoat to slow down the drying time of any paint applied on top of it; this allows you more time to blend paints together and get a smooth effect.

1. Apply a basecoat of ultra-marine. Allow to dry.

2. Evenly cover the basecoat with a thin coat of retarder. Wipe the brush on absorbent paper then stroke it back over the retarder to remove any excess. Continue until you have an even, shiny surface.

Note

Acrylic paint worked over retarder takes a long time to dry, so a hairdryer should be used. It is important to ensure that the first coat is thoroughly dry before applying the next layer of retarder; allow the surface to come back to room temperature before doing this.

Retarder will allow you to play with the paints applied over it for quite some time. However, it will gradually dry, and patches of paint may then start to lift off. If you find that your paint is not moving easily, stop and dry thoroughly with a hairdryer. When the surface is cool, reapply a layer of retarder and continue blending your paint as before.

Retarder should be applied sparingly. If you find that your paint is swimming around on the surface and not blending with the other colours, you have applied too much retarder. If this happens, wipe it off and start again.

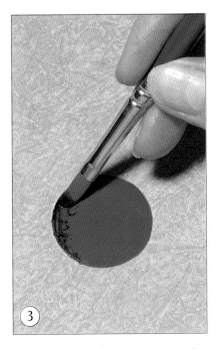

(3)

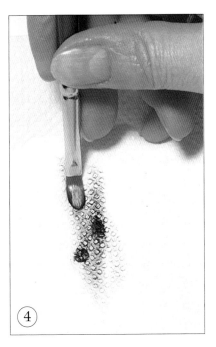

(4)

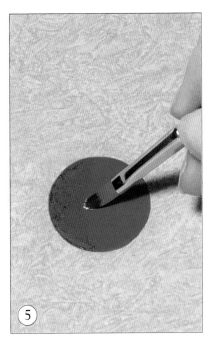

(5)

3. Apply Payne's grey to one side of the circle with a dry filbert brush.

4. Wipe the brush on absorbent paper to remove excess paint.

5. Pull the colour in towards the centre.

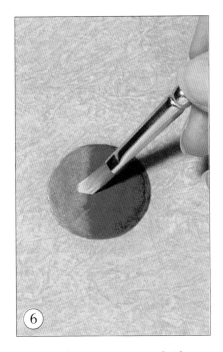

(6)

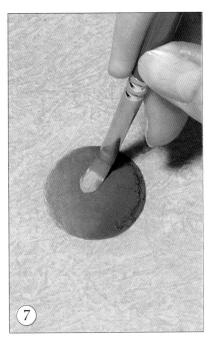

(7)

7. Wipe the brush to remove any excess paint. Now pat and blend the two colours down the centre so that they fade into the background. Keep wiping the excess paint off the brush during blending. Use a hairdryer to dry the paint and retarder. Repeat the stages shown here to build up more shading and to add further colours as required.

6. Turn the image around. Clean your brush then repeat stages 3-5 on the opposite side of the circle using warm white.

Leaves

The pat-blending technique allows you to build up additional colours. Try adding small amounts of colour into any leaves that are in the focal point of your design. If you want a leaf to appear in the distance or fade into the background, blend a little of the background colour into the edge of your leaf. This will also help to harmonise your design.

You should bear in mind the same points when painting leaves using the pat-blending technique, as when painting them using the side-loading technique (see page 26).

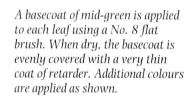

A basecoat of mid-green is applied to each leaf using a No. 8 flat brush. When dry, the basecoat is evenly covered with a very thin coat of retarder. Additional colours are applied as shown.

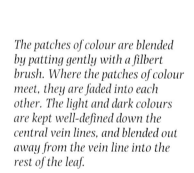

The patches of colour are blended by patting gently with a filbert brush. Where the patches of colour meet, they are faded into each other. The light and dark colours are kept well-defined down the central vein lines, and blended out away from the vein line into the rest of the leaf.

Flowers

You can use the pat-blending technique to paint flowers. This method will allow you to create wonderfully subtle shades and tones which will bring your flowers to life.

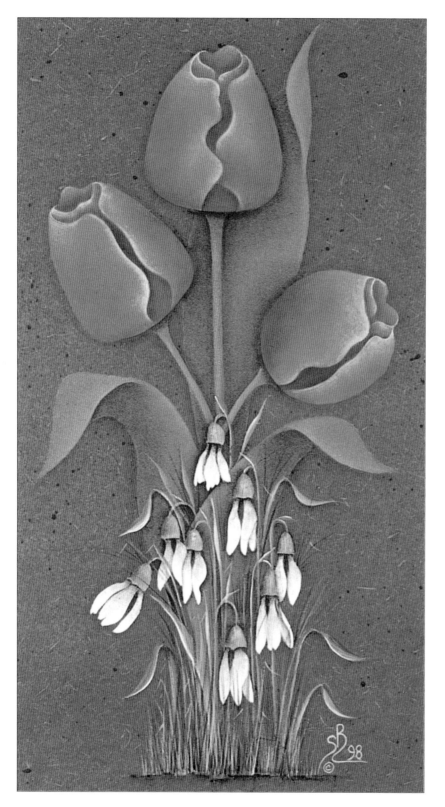

Tulips and snowdrops

Tulips were first cultivated in the Turkish court in the early sixteenth century. Fortunes were made in the European bulb trade during the seventeenth century, with single tulip bulbs fetching the equivalent of thousands of pounds. Tulips have featured in traditional folk art designs for hundreds of years, and they were originally painted to symbolise the Holy Trinity.

Snowdrops also feature in this design. These are sometimes referred to as 'purification flowers' as they are associated with the religious festival, Candlemas, which celebrates the Feast of the Purification of the Virgin Mary and the presentation of Christ in the Temple.

This design has been painted using the pat-blending technique shown on pages 48–49. The side-loading technique shown on page 24 has been used for the final stages of each flower. A filbert brush is used throughout unless otherwise specified.

I have worked this design on a subtle woodstained background. If you are not working on a wooden surface, use one of the decorative backgrounds featured on pages 14–23.

You will need

- acrylic paint: rose pink;
 Norwegian orange; Turner's
 yellow; warm white; yellow
 light; Payne's grey; raw sienna;
 burnt sienna; raw umber; green
 oxide; carbon black
- No. 8 flat brush
- No. 1 round brush
- basecoating brush
- liner brush
- filbert brush
- stipple brush
- retarder
- transfer paper
- masking tape
- tracing paper
- stylus
- soft pencil or felt-tip pen
- clear glaze medium
- dry cloth
- old toothbrush

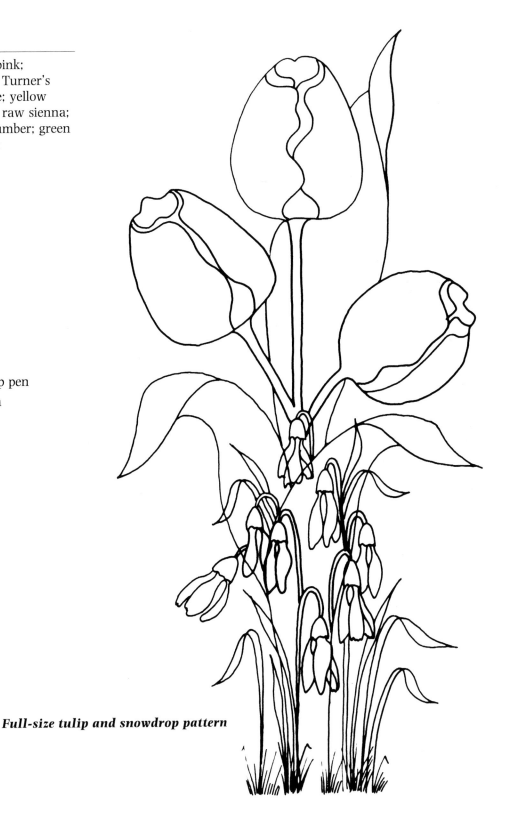

Full-size tulip and snowdrop pattern

- **LIGHT PINK**

 Norwegian orange + rose pink + warm white (2:1:8)

- **DARK PINK**

 Norwegian orange + rose pink + warm white (2:1:1)

- **DARK ORANGE**

 Norwegian orange + a touch of Payne's grey

- **DARK GREEN**

 green oxide + Turner's yellow (1:1) + a touch of carbon black

- **VERY DARK GREEN**

 dark green + a touch of Payne's grey

- **MEDIUM GREEN**

 green oxide + Turner's yellow (1:1)

- **LIGHT GREEN**

 medium green + yellow light (1:1)

- **BROWN**

 raw sienna + burnt sienna + raw umber (1:1:$^1/_2$)

Creating the background

Apply a basecoat of neat clear glaze medium to your surface using a basecoating brush. Allow to dry. Make up a woodstain by using a 50/50 mixture of brown paint with clear glaze medium; this will produce a semi-transparent mixture which, when applied to wood, will allow the grain to show through. Brush this mixture on to your surface. Remove brushmarks by wiping off any excess with a dry cloth. Dip an old toothbrush in raw umber, then flick the bristles to speckle the surface with paint. Leave to dry, then transfer the design on to the woodstained surface (see page 31).

Painting the design

Stage 1

Leaves: Use a No. 8 flat brush to apply a medium green basecoat.

Tulips: Apply a basecoat using a No. 8 flat brush and dark pink. Allow to dry. Transfer the internal petal lines on to the painted surface.

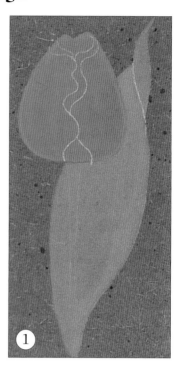

Stage 2

Leaves: Paint a thin coat of retarder on to the leaves. Apply dark green shading and light green highlights, then pat-blend these two greens where they meet. Allow to dry.

Tulips: Paint retarder on to the flowers. Pat-blend light pink highlights, working outwards so that the colour fades into the background. Allow to dry.

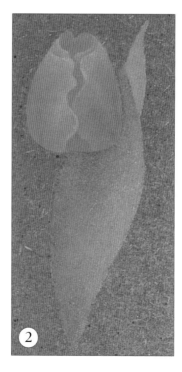

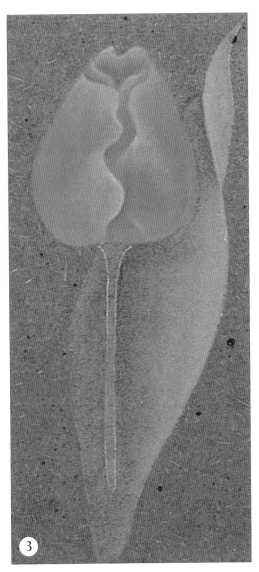

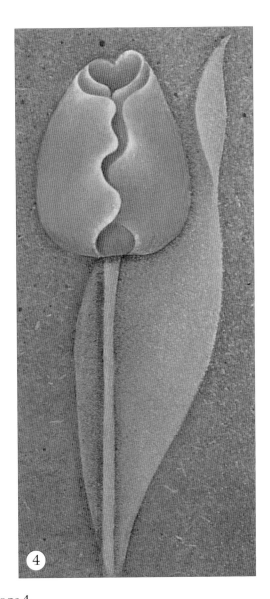

Stage 3

Leaves: Transfer the stalk lines on to the painted surface. Apply retarder to the leaves. Build up very dark green shading on each side of the stalks and under the curl of each leaf. Highlight the top of each leaf curl and leaf edge in light green. Allow to dry.

Tulips: Apply retarder to the flowers. Pat-blend on patches of rose pink, Norwegian orange and Turner's yellow as shading. Blend the colours well where they meet. Reinforce highlights here and there with warm white. Allow to dry, then repeat this stage if necessary, until the desired effect is achieved.

Stage 4

Leaves: Apply retarder to the leaves. Paint the stalks in medium green and pat-blend yellow light high-lights down one side. Allow to dry. Shade down both sides of each stalk and under the leaf curls using a side-loaded No. 8 flat brush and very dark green. Shade raw umber around the outside of the leaves.

Tulips: Use the side-loading technique and warm white to enhance the highlights, and use dark orange for the shading inside the flowers. Add the green area at the base of the flowers with the tip of a liner brush. Vary the lengths of the strokes to give a gradated effect. Use a No. 8 flat brush and raw umber to shade around the outside of the flowers and under the base.

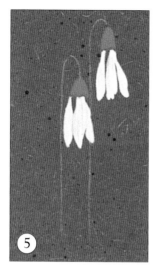 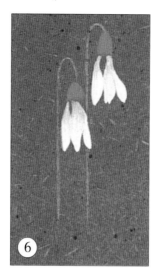 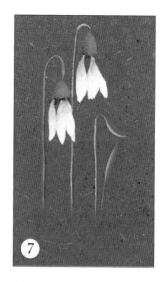 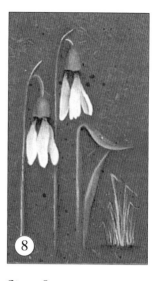

Stage 5

Snowdrops: Use a No. 8 flat brush to apply a basecoat of warm white to the petals and medium green to the cups. Allow to dry.

Stage 6

Snowdrops: Apply retarder to the petals. Pat-blend medium green at the base of the petals, fading out half way down the petals. Allow to dry.

Stage 7

Snowdrops: Apply retarder to the petals and the cups. Pat-blend very dark green at the base of each petal and on one side of each cup. Pat-blend yellow light on the other side of each cup and along the bottom edge. Paint the leaves and stalks in medium green using a No. 1 round brush. Allow to dry. Apply retarder to the stalks, then pat blend on highlights using warm white. Allow to dry.

Stage 8

Snowdrops: Use the side-loading technique and Payne's grey to shade the base of the petals and in between each petal. Highlight along the bottom edge of each cup in yellow light using a No. 8 flat brush. Use a dry stipple brush and a little warm white to add the final highlights to the middle of the cups. Use a No. 8 flat brush and raw umber to shade around the outside of the leaves and flowers. Slightly extend the stalks using the same method as described in stage 7.

Grass: Paint in fine lines in the grass area using a liner brush and yellow light, warm white and all the shades of green to create variety and depth. Shade raw umber into the base of the grass.

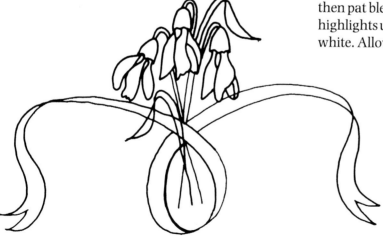

Full-size snowdrop and ribbon pattern

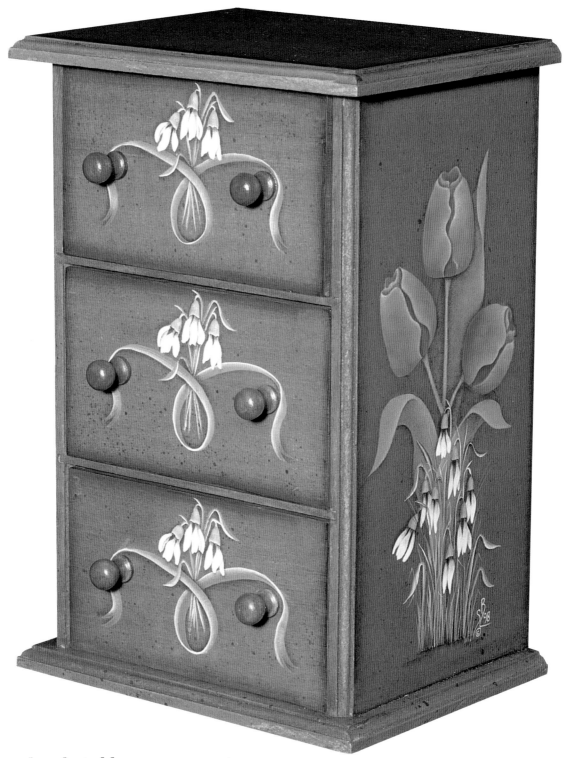

Tulip and snowdrop chest of drawers

I have added a further design to the front of this miniature chest of drawers. The pattern for this can be found opposite. The ribbon is painted in the same way as described on page 38, using a basecoat of dark pink, with light pink highlights. Raw umber is shaded around the outside of the ribbon. You can follow stages 5–8 to paint the snowdrops.

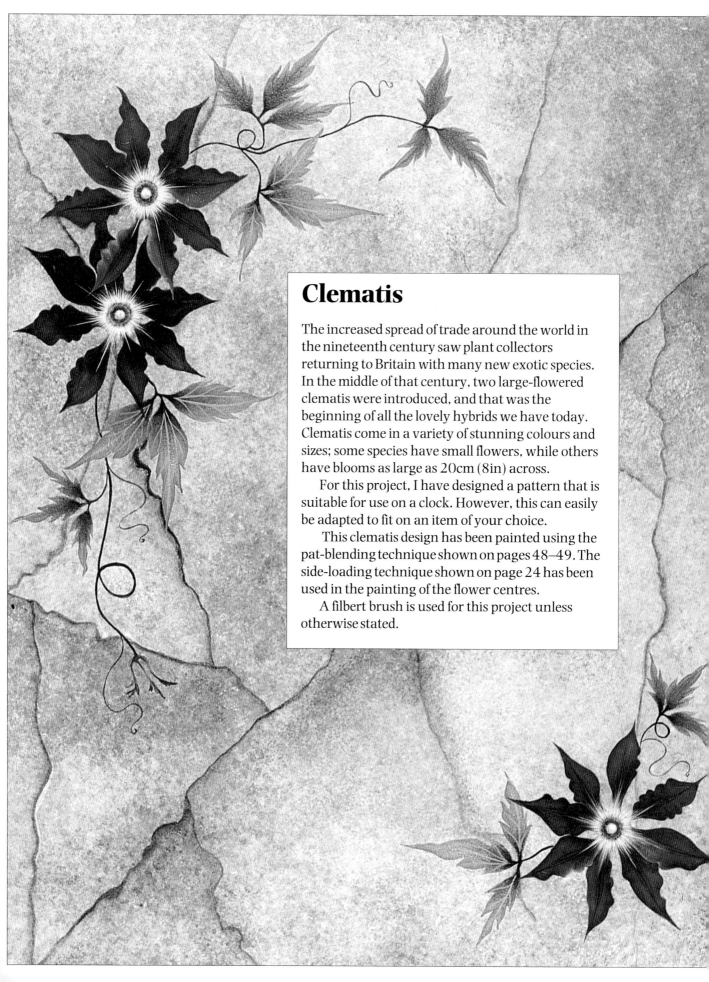

Clematis

The increased spread of trade around the world in the nineteenth century saw plant collectors returning to Britain with many new exotic species. In the middle of that century, two large-flowered clematis were introduced, and that was the beginning of all the lovely hybrids we have today. Clematis come in a variety of stunning colours and sizes; some species have small flowers, while others have blooms as large as 20cm (8in) across.

For this project, I have designed a pattern that is suitable for use on a clock. However, this can easily be adapted to fit on an item of your choice.

This clematis design has been painted using the pat-blending technique shown on pages 48–49. The side-loading technique shown on page 24 has been used in the painting of the flower centres.

A filbert brush is used for this project unless otherwise stated.

- clock front and mechanism
- acrylic paints: dioxide purple; warm white; Turner's yellow; yellow light; Indian red oxide; moss green; Payne's grey; transparent magenta; carbon black; burgundy
- extender
- No. 8 flat brush
- No. 1 round brush
- liner brush
- stipple brush
- mop brush
- basecoating brush
- transfer paper
- tracing paper
- stylus
- masking tape
- soft pencil or felt-tip pen
- chalk or watercolour crayon
- retarder
- natural sponges: 1 coarse, 1 fine
- palette knife
- ink nib
- compass

Pattern for the clematis clock

Enlarge on a photocopier by 200%

- **DARK BURGUNDY**

 burgundy + a touch of carbon black

- **MEDIUM PURPLE**

 dioxide purple + a touch of warm white

- **LIGHT YELLOW**

 Turner's yellow + warm white (1:1)

- **LIGHT GREEN**

 yellow light + a touch of carbon black

- **MEDIUM GREEN**

 light green + a touch of carbon black

- **DARK GREEN**

 medium green + a touch of carbon black

Creating the background

Prepare the background in the same way and using the same colours as shown in the realistic marbling demonstration on page 22. Leave to dry before transferring the design (see page 31).

Painting the design

Stage 1

Clematis: Use a No. 8 flat brush to apply a basecoat of medium purple to the flowers. Leave to dry, then transfer the internal petal lines on to the painted surface.

Leaves: Apply a basecoat of light green to the leaves using a No. 8 flat brush.

Stage 2

Clematis: Paint retarder over the flowers. Pat-blend dioxide purple along the edges of each petal, fading out towards the petal centres.

Leaves: Apply retarder to the leaves. Pat-blend dark green at the base of each leaf, fading out towards the tips.

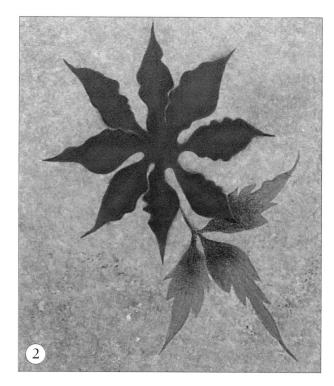

Stage 4

Clematis: Stipple a circle in the centre of each starburst in Indian red oxide. Stipple a smaller circle inside that one in moss green. Stipple a highlight on one side of the green circle in warm white. Use the side-loading technique and a No. 8 flat brush to shade around the outside edge of each circle in Payne's grey.

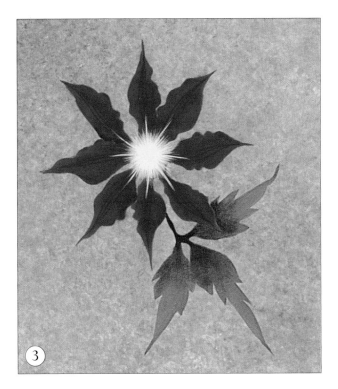

Stage 3

Clematis: Pat-blend transparent magenta up the centre of each petal. Allow to dry. Use a liner brush and transparent magenta to paint three lines up the centre of each petal. Paint a starburst in the centre of each flower using the tip of a liner brush and light yellow. Work from the centre outwards and build up the strokes gradually by going over and over the same area. Extend the lines slightly up each petal.

Leaves: Pat-blend yellow light at the tip of each leaf, fading out towards the middle. Use a liner brush to paint each stalk in Indian red oxide, and bring the colour up on to the base of each leaf. Pat-blend where the Indian red oxide meets green to blend the colours. Allow to dry.

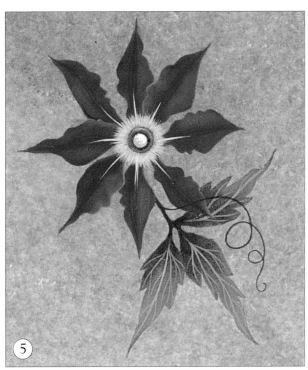

Stage 5

Clematis: Paint a few highlights on the edges of the petals using a side-loaded No. 8 flat brush and warm white. Where two flowers overlap, make the petals that are on top lighter, and those that are underneath darker.

Leaves: Paint the veins with a liner brush using medium green. Add tendrils to the stalks using a liner brush and Indian red oxide.

Stage 6

Clock face: Transfer the design on to the painted surface. Use an ink nib and dioxide purple to draw on the clock face, and use a liner brush for the line work around the outside. To paint the numbers, fully load a No. 1 round brush with dioxide purple. Press the brush down on the surface to splay the hairs. As you move the brush towards you, lift it very gradually and allow the hairs to come back into a point to create the thin end of the stroke: this is known as the comma stroke.

Assemble the clock hands and mechanism following the manufacturer's instructions.

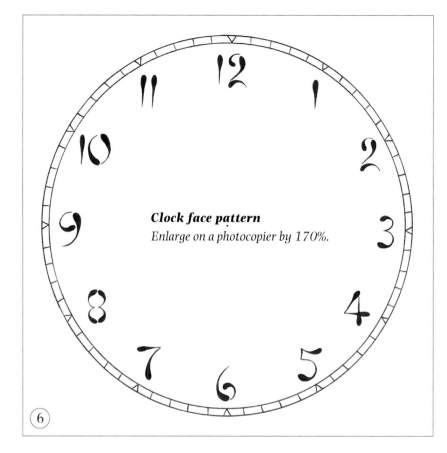

Clock face pattern
Enlarge on a photocopier by 170%.

(6)

Note

An ink nib is useful for drawing circles or straight lines.

Loading the ink nib	*Drawing a circle*	*Drawing a straight line*
Thin your paint with a little extender until it is the consistency of single cream. Load the tip of a palette knife with paint, then hold it against the reservoir of the pen so that it drips down into the nib.	*Fit the ink nib on to a compass. Extend the compass to create the desired circumference. Move the nib carefully to form a circle, leaning into the curve as you work.*	*Hold a ruler in place on your drawing surface, then run the ink nib along the edge of the ruler, holding the pen upright.*

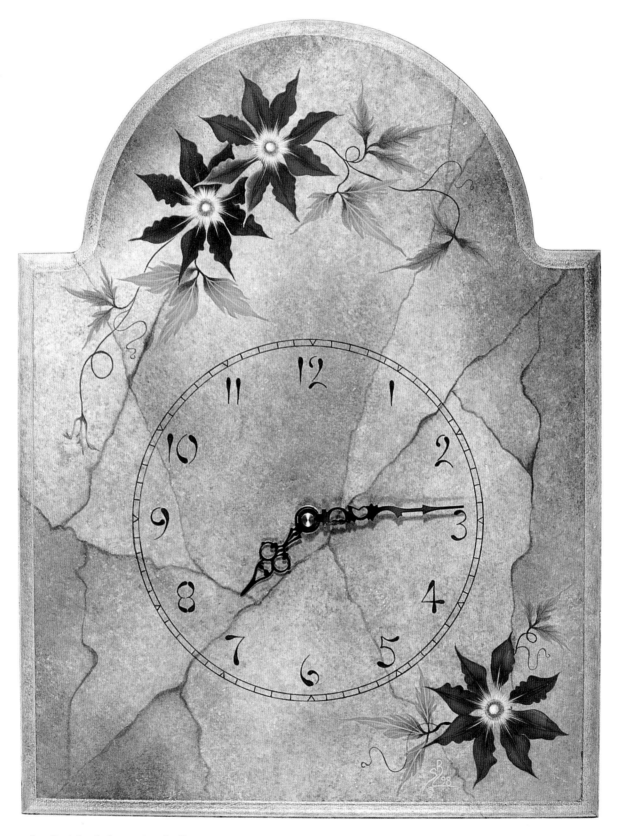

The finished clematis clock

Index